Warehouse number one at the entrance to the harbor. This famous landmark is said to be haunted as well.

HAUNTED
SAN PEDRO

BRIAN CLUNE FOREWORD BY BARRY CONRAD

Haunted
America

Published by Haunted America
A Division of The History Press
www.historypress.net

First published 2016

All photographs are by the author unless otherwise noted.

Manufactured in the United States

ISBN 978.1.46713.577.1

Library of Congress Control Number: 2016936701

My family has to put up with so much as I write that I sometimes wonder how they can live with me. This book is dedicated to my wife, Terri; my two sons, Carmel and Joshua; and my daughter, Amberly. Thank you for always believing in me and encouraging me to pursue my dream of being a writer. I love you guys.

The beauty of the glass expanded the spirit, let it loose among the clouds and in nature.
—author Anais Nin after visiting the Wayfarers Chapel

CONTENTS

FOREWORD

When originally asked to pen the foreword to Brian Clune's new book titled *Haunted San Pedro*, I was impressed that someone of Brian's acumen had an interest in things that defied explanation, namely stories and legends of a ghostly nature said to inhabit the Rancho San Pedro area, which is rich in history and represents one of the first California land grants, not to mention the first to win a patent in the United States by the Mexican government.

Brian wanted to delve into the mysteries residing in areas such as the Fort McArthur Museum, the spectrally infested Drum Barracks in Wilmington, the USS *Iowa*, the Vincent Thomas Bridge and other haunted places where spirits have been reportedly cropping up over the years, including the noisy poltergeists that apparently clomp up and down the long, winding staircase at the historic Point Fermin Lighthouse, which once had a family of ten living there.

I've often wondered if the primal element of water itself somehow has an influence over areas such as San Pedro when it comes to spurring on ghostly manifestations. After all, the earth itself was once covered by it back in primordial times, and if it weren't for the existence of water on this planet, no worldly life could exist. So it is that the great Pacific borders San Pedro and the entire Rancho Palos Verdes Peninsula. And of course, the Port of Los Angeles, located within San Pedro, is a major international seaport.

On this business of landmasses poised in proximity to large bodies of water attracting a greater number of occult case studies, it is a common theory among supernatural researchers that where there is water, often there

is paranormal activity. A building with an open well in its basement or a structure constructed on an underground spring may harbor more spirit entities than those built on dry earth. Author Troy Taylor once described a situation in which a gymnasium back in the Midwest was built over an underground lake and the roar of the crowd can still be heard long after the games have concluded. Perhaps when the natural environment is conducive, the spectral sounds of long-distant memories can somehow be played back once again as if the witnesses were temporarily locked into a *Twilight Zone*–like replay of forgotten memories trapped in time.

Most people who visit the San Pedro area are surely impressed by its grand vistas overlooking the blue expanse of the ocean that, depending on their point of reference, sometimes afford a distant glimpse of nearby Catalina Island, an enchanted island attracting millions of tourists each year to partake of its seasonal wonders. It is the pristine beauty and tranquil nature of this watery setting, ideally portrayed on picture postcards, that invite our interest in the exotic side of things. People who come here are so entranced with the land's inherent beauty and vistas with nary a thought for things of a more macabre and perplexing nature. However, the land and its majestic bluffs as framed by the splendor of the nearby coastal sea sometimes call out to us in a different language, evoking mysteries of a forgotten past or lost stories of real people who lived and lost their lives here, perhaps in unknown or homicidal incidences. Perhaps even a hint of the native Tongva Indian culture that inhabited these shores long ago sometimes springs to life, an indistinct voice or a tribal drum evolving out of the mists. How many unsolved deaths relating to the sea itself are hiding beneath the waves of time? No one knows for sure. Except for rare written accounts, time has eroded the memories lost in the ever-expanding fabric of the ages. However, there is one major story contained within the pages of this book that I can avow to be factual and quite extraordinary since I was present and completely involved as the lead investigator of this case back in 1989.

"A Haunting on Eleventh Street" actually took place several blocks south of Gaffey in one of two small twin bungalows built at the turn of the century. A young woman named Jackie Hernandez, recently separated from her husband (Al Hernandez) and living with her three-year-old son, Jamie, and infant daughter, Samantha, would become the victim of one of the most bizarre poltergeist cases of all time.

In the late '80s, I worked with Dr. Barry Taff, noted parapsychologist, who studied under Dr. Thelma Moss (*The Probability of the Impossible*) at UCLA at a time when an actual parapsychology lab had been instituted for

studying "things that go bump in the night." It was he and fellow student Kerry Gaynor who investigated a woman living in Culver City named Doris Bither, who claimed to have been not only physically assaulted but also carnally raped by three invisible creatures living in a house similar in size to Jackie's. The case was eventually novelized by writer Frank DeFelitta, who based his story on personal experiences at the Bither home after a full-bodied apparition, bathed in a lime-green light, manifested in front of not only himself but also his protégé, Mort Zarkoff, along with a bevy of UCLA students staked out inside the woman's bedroom in 1974. The story gained even greater notoriety with the release of the 20th Century Fox movie version of *The Entity* in 1983, starring Barbara Hershey.

The San Pedro case in which I became embroiled was initiated by a woman named Susan Castaneda, a neighbor of Jackie's, who contacted Taff after seeing him on a local TV show (*LA Now*) featuring a segment on occult stories around Los Angeles. He, in turn, contacted me and invited me to rendezvous with him and several friends in San Pedro to interview the woman and her neighbors about the paranormal experiences they were reporting within the small frame home. At the time, I had already gone on several forages into the unknown with Taff, having thus far yielded little in the way of tangible phenomena, so I had no expectations whatsoever that this case would be any different. Boy was I mistaken! I had persuaded a skeptical associate and friend of mine named Jeff Wheatcraft to come along and check out the case since he had professional photographic gear, and coupled with my pro video camcorder, we agreed to meet Taff and his cohorts at the Eleventh Street home.

Interestingly enough, on the warm, sultry summer night of August 8, we visited the bungalow in San Pedro and were immediately greeted by the pungent smell of iodine that seemed to emanate from a small laundry room located off the kitchen area toward the rear of the home. Above this room there was a small rectangular crawlspace door that led to an attic above. It was this attic that would serve as the catalytic Pandora's Box soon to be violated by our entry into the looming darkness above. For it was in the unholy darkness of this peculiar little attic that the impossible would come to pass. Otherwise referred to as the "San Pedro Haunting" or the "Haunting of Jackie Hernandez" (please see the documentary video *An Unknown Encounter*), here was a story that I had personally witnessed and survived. When I say "survived," you will hopefully come to an understanding after perusing Brian's chapter on this particular episode that this haunting nearly cost the life of a fellow researcher and involved a vengeful spirit not only

intent on haunting a young divorcée living on welfare but also with the ability to transmogrify into a "have ghost will travel" story, as manifested by its uncanny ability to leave the San Pedro home and follow us back to our own domiciles. Without a doubt, this entity had abilities and powers unlike anything I've ever investigated in the realm of the supernatural and was life changing to say the least.

The spirit residing on Eleventh Street at the time was definitely one to be reckoned with. Lamps flew from tables, crashing to the floor, and a shadow-like figure floated near the living room ceiling, terrifying the female tenant and sometimes coalescing into a full spectral form resembling a corpse-like old man wearing high-water pants and a red flannel shirt as the witness sat demurely, blankly staring at the specter in silent horror.

Having had experience with video cameras since I started out as a news cameraman at WKRC-TV in Cincinnati followed by a six-year stint at NBC's KOA news station in Denver in the early '80s, it was my intention to utilize the video equipment to my advantage in attempting to document otherworldly events, if indeed they existed. It was spooky enough to hear all these incredible stories of the supernatural from ghostly witnesses, but it would prove to be another thing to actually document them on videotape. For me, the camera would move it up a notch, if possible, in confirming the reality of something existing apart from this world. While eyewitness accounts of the supernatural were compelling in their own right, with the camera in hand as a second and more indelible testimony, the account would no longer represent the proverbial "fish that got away" story. In essence, the creature that inhabited the dark abode of Jackie Hernandez lived in a quasi-dimensional world, evasive and mystifying, yet with the ability at a moment's notice to strike fear and panic in the hearts of anyone who crossed its path.

In keeping my trusty video equipment close at hand, I would ultimately be vindicated in my quest for the unknown. Throughout the case, I began picking up multiple corpuscular balls or rods of light darting about the premises. At times, the lights had a pea-pod structure revealing three inherent luminous spheres joined together, flying through the air, even right through Jackie's head! Dr. James Robin, a noted aerospace physicist with Rockwell International, confirmed on national television (*A Current Affair*) that my camera equipment had definitely recorded phenomena of an unexplained origin.

Not only was I able to objectively document these glowing anomalies, but fortunately, I was also rolling my camera when violent supernatural attacks

were enacted on those of us investigating the haunting. This case, without a doubt, gave me a completely different perspective on ghost hunting in general. It became apparent that all of us were dealing with something truly frightening and inexplicable. The sad truth became readily apparent in that we were made cognizant that at any given moment, one of us might have easily succumbed to the specter's wrath, which, on occasion, seemed relentless and unpredictable in its haunting terror.

Ghosts have been sighted since time immemorial, and they do not appear to have any intentions of going away in spite of the onset of increased secularism pervading western society today. In the Hernandez case, the infesting spirit proved itself to be more than just another whimsical haunt; moreover, it gave every sign that it could simply be evil. Despite present-day dogma that frequently espouses the notion that entities cannot harm the living, the San Pedro case demonstrated just how little we know about supernatural phenomena. Undoubtedly, when it comes to a progression of studies regarding the elusive poltergeist, I firmly believe we are at the tip of a massive iceberg in terms of understanding the vagaries of the unknown.

While few ghostly incidents originating in the Rancho San Pedro area can be classified as scary and violent as I've briefly described here about the Eleventh Street incident, the stories contained in Brian's book, I hope, will not only inform you about reportedly true and historic instances of paranormal contact, but I should think they will also encourage an open-mindedness on the part of the reader to observe the world in a different light. For as I learned so many years ago during the Jackie Hernandez ordeal, there is something out there riding along on the coattails of the wind that seems to cry out to us from an unknown void in a cryptic language, the language of fear, thought and shapes—probably the same repertoire of fear-inducing phantoms that have always haunted men in their times. And somewhere in that forbidden world, a ghostly cry may once again emerge from the unearthly void, challenging us to pursue its darkest secrets. Enjoy!

BARRY CONRAD

ACKNOWLEDGEMENTS

I would like to thank The History Press for taking a chance on me once again and allowing me to write for them. Thank you to Megan Laddusaw, my acquisitions editor, for putting up with my incessant questions while I was working on the manuscript, and my family, of course. Thanks as well to Bob Davis of Planet Paranormal, who started me on this incredible journey, along with Ash and Laurel Blackwell; you three are part of my extended family, and I love you guys. I would most like to thank my brother-in-law and sister-in-law, Lewis and Valerie Fontenot, for being my chauffeurs and driving me all over the city so I could take pictures for the book. I know they were embarrassed every time they had to hear me ask people about ghosts when visiting the locations, but the looks on their faces were worth it. Last but not least, thank you to my wife, Terri, who is my spell checker, editor and the one person able to keep my head out of the clouds and my feet on the ground.

Chapter 1

SAN PEDRO

The Most Beautiful Place on Earth

Just outside Los Angeles, attached to the giant city by a twenty-eight-mile narrow strip of land known as the "Harbor Gateway," is the port town of San Pedro. This thriving town was once a city of its own with a city hall, its own fire and police departments and one of the busiest harbors in the country. It was also a navy town for the Pacific Fleet. It was annexed by the sprawling city of Los Angeles in 1909 because the metropolis wanted its port facilities and the revenue that came with it. Today, the Port of Los Angeles is the busiest port in the country and surpassed only by Hong Kong and Singapore as the busiest harbor in the world, with millions of tons of goods passing through its docks yearly, headed to all four compass points of the United States and beyond.

San Pedro sits at the southern tip of the Palos Verdes Peninsula and was originally inhabited by the Tongva-Gabrieleno Native Americans. They had lived on the site for thousands of years, as well as in other wide-ranging areas around the Los Angeles Basin. They had been there for so long, in fact, that they believed they had been there since the beginning of time itself.

The Tongva were masters of the sea and called themselves "Lords of the Oceans." This was not just an over-blown ego speaking but also a true belief in themselves and their tradition of building and sailing their oceangoing canoes, or *ti'ats*. Catalina Island (named Pimu by the Tongva) was only twenty-six miles across the San Pedro Channel, and the Tongva would paddle their canoes across the sometimes-treacherous ocean to trade with their fellow tribesmen, who called themselves Pimungans. They would trade

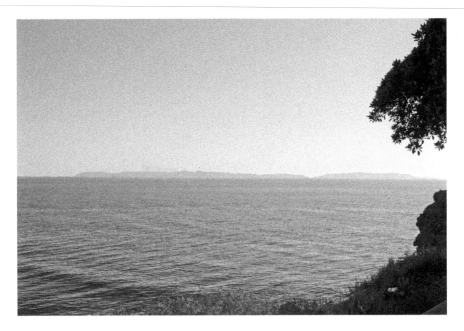

The view from atop Point Fermin of Catalina Island—sometimes the last sight of those too despondent to live.

for shells, mollusks, island fish and seafood and give the islanders goods that were not available on the island itself.

Catalina was not the only island that the San Pedro natives traded with; at this time, all the Channel Islands were inhabited as well, as were many colonies spread up and down the coast of California, and the Tongva plank canoes sailed far and wide, trading with them all. The Tongva lived in relative peace, and it is said that they blessed the land of Palos Verdes, which they called Chaaw, which made it the most beautiful place on earth. However, all of this would change around 1542, when the first Europeans arrived.

Juan Cabrillo was a Portuguese explorer sailing under the flag of Spain and was the first European to discover the natural harbor at the northwest end of the bay. He named the area Bahia de Los Fumas, or Bay of Smokes. He gave it this moniker due to the smoke he saw coming from the Tongva hunters' cook fires as they prepared meals in their camps. The following day, Santa Catalina Island was discovered, along with its inhabitants. Cabrillo explored as much of the harbor as he could, but because the water was very shallow, this exploration was limited. The harbor carried the name Cabrillo had given it for 50 years, until 1602, when Sebastian Viscaino, who was officially mapping and surveying the coastline of California for Spain, sailed

into the bay and renamed it Ensenada de San Andres in honor of Saint Andrew. Viscaino mistakenly thought that he had arrived on the feast day of Saint Andrew, but in actuality, it was the day in honor of Saint Peter, the bishop of Alexandria. It would take 132 years for his mistake to be known, but when Cabrera Bueno discovered it, he immediately changed the name to San Pedro in honor of the martyred saint, and we have known it as such ever since.

The area remained mostly undisturbed until 1769, when Spain decided that it should make an effort to populate California and began creating settlements. This expansion coincided with Father Junipero Serra's work of creating a mission system extending the length of Spanish-held territory. Each of these missions was to be spaced out a day's ride from the next to not only bring Christianity to the natives but also to provide a place of rest for weary travelers. Two of these missions—San Gabriel (1771) and San Juan Capistrano (1776)—were supplied twice a year, and the supply wagons would return with tallow and hides produced by the missions to San Pedro, where they were loaded onto ships to be delivered to other Spanish holdings. Spain also brought in over eleven families to help settle the area, and they set up their small town twenty miles north of the harbor near the Tongva village of Yang-na. They named this settlement El Pueblo de Nuestra Señora La Reina de Los Angeles Porciuncula on September 4, 1781. Unfortunately, Spain made it illegal to trade with anyone other than Spanish colonies, and this restriction encouraged smugglers to bring in goods from all over the world to be sold to the settlers; in fact, smuggling became the mainstay of trade for the new settlers. The first American trading ship, the *Lelia Bryd*, made port call in San Pedro in 1805, and even though the trade restrictions were still in place, the distance from Spain along with loose enforcement allowed trade to thrive.

Juan Jose Dominguez was a member of the 1769 Portola Expedition to Alta California, and as a reward, Mexican governor Pedro Fages awarded him the first land grant recorded in California. This grant became the 75,000-acre Rancho San Pedro. The boundaries of this new rancho spread from Redondo Beach to Compton and Long Beach and included San Pedro proper, as well as all of Palos Verdes. The rancho flourished under Dominguez's guidance even after the Mexican war for independence and New Spain became part of Mexico in 1821; however, over the years a dispute erupted between Dominguez and the Sepulveda family. Around 1835, the tensions between the two parties worsened, and Governor Jose Figueroa, in a bid to settle the dispute, granted Juan Capistrano Sepulveda and his

brother Jose Loreto Sepulveda 31,600 acres of the Dominguez Rancho. This included all of Palos Verdes and the town of San Pedro as well. This new rancho became known as Rancho Palos Verdes.

By 1835, San Pedro had become the most important port on the West Coast, yet the ships still had to moor about a mile off shore, and their passengers and cargo had to be transferred by small boat into the port proper. These tiny boats not only had to battle the ocean tides but several small islets as well, some of which would just appear out of the bay at low tide and could cause havoc with the small craft coming into port. One of the worst of these was Dead Mans Island, aptly named for how many ships broke up on its rocky shore during storms. The Sepulvedas built a crude dock near present-day Fourteenth Street and Beacon, which became known as Sepulveda's Landing.

In 1851, a young man by the name of Phineas Banning arrived in San Pedro with dreams of becoming rich. Banning had come from the East Coast of the United States and had arrived at the port of San Pedro just after the United States gained control of California following the defeat of Mexico in the Mexican-American War. He immediately saw the potential for the harbor and the growing city of Los Angeles as well. Banning fought tirelessly to grow the port, lobbying the federal government in Washington, D.C., and going so far as to dredge the harbor using his own funds to allow large oceangoing ships to dock within the confines of the harbor itself. This allowed for easier offloading and loading of the vessels, as well as a much safer environment, which greatly improved the port's image around the world. Once the government decided to officially recognize the Port of San Pedro (now the Los Angeles Harbor), the growth of the area became rapid, and by the time of the American Civil War, the harbor was one of the most important links in the supply chain for Union troops. Washington sent larger and larger contingents of the army and navy to help protect it, as well as the other major ports of California. Today, the Los Angeles Harbor is not only an integral part of America's transportation system but its busiest port as well.

Chapter 2

THE DOMINGUEZ RANCHO

In 1784, King Carlos III of Spain granted seventy-five thousand acres of land to Juan Jose Dominguez. This was the first Spanish land grant in California and was granted to the family because of the service given by Dominguez to the Crown. The area stretched from what is now Redondo Beach to Long Beach and Compton to the Palos Verdes Peninsula, including the Los Angeles Harbor, Terminal Island and Wilmington. The area became known as Rancho San Pedro. Dominguez built his home inland from the coast, and this adobe became the center for the whole area. It is said that the adobe is haunted by at least one spirit and perhaps more.

Juan Dominguez arrived in the New World in 1769 with the Portola Expedition, which paved the way for colonization of Las Californias by Spain. Gaspar de Portola and Junipero Serra traveled north from Baja all the way to San Francisco Bay. They marked areas for colonization along with the locations where Serra would establish his missions, each within a day's ride from the next. Dominguez, at the time, was a soldier in the Spanish army, and his job was to protect Portola and Serra, along with the horses and supplies for the entire troop. After the successful completion of the expedition, Dominguez was stationed at the Presidio of San Diego and would eventually become the prefect. Dominguez was getting up in years and held the prefect's office for only a short time before he began planning for retirement. Knowing Dominguez's wishes, his friend Pedro Fages, who had been on the Portola Expedition with him and was now governor of Alta California, granted Dominguez seventy-

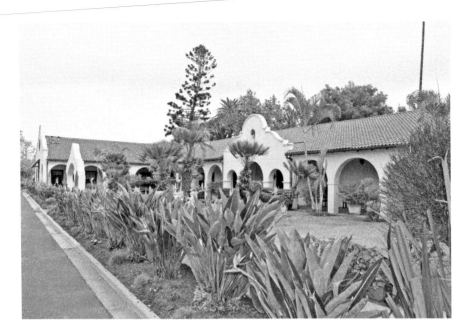

The adobe ranch house.

five thousand acres of land; once it was approved by Spanish king Carlos III, it became the first such grant given in California.

Dominguez was still living in San Diego after he retired but visited his rancho off and on until his death in 1809. He named his rancho San Pedro in honor of Saint Peter and stocked it with large herds of horses and cattle that he owned and kept on government property down in San Diego. Getting up in years, Dominguez hired a *mayordomo*, or manager, to oversee the day-to-day operations of Rancho San Pedro and had several small buildings constructed to house and feed the *vaqueros* who worked on the rancho. Unfortunately, he did not have any children and, therefore, no heir. By the time he moved to Mission San Juan in Capistrano due to failing eyesight, he had made arrangements for his nephew Cristobal to inherit the land. Because his health was failing rapidly, Dominguez hadn't realized that his mayordomo had been allowing a friend, Juan Sepulveda, to use some of the rancho for his own purposes, and this would come back to haunt the Dominguez family later on in a big way.

Cristobal Dominguez was also a soldier serving in the Spanish army and was stationed at the mission in Capistrano, where his uncle had been living out his retirement. After inheriting Rancho San Pedro (some called it Rancho Dominguez), he placed his son Manuel in charge of the land and

its operations. The Sepulvedas were still working their area, and Cristobal saw no reason to remove them. Manuel built several small adobes on the property for the ranch hands and mayordomo to live in, but because he never intended to live there himself, no formal abode was constructed. There was a bit of confusion caused by the transfer of the property into Cristobal's name when his uncle died, along with the massive size of the rancho itself, so in 1817, Cristobal requested that the Spanish government re-grant the land in his name. The request had the added benefit of having the land surveyed for the first time so the boundaries could be fully mapped. A sycamore tree was used to mark the northernmost boundaries of the rancho; this tree still stands today at the corner of Poppy and Short Streets in Compton, California. Once the survey was finished, it established Cristobal as the sole landowner of the rancho. This allowed him to transfer all rights to Rancho San Pedro to his wife and children when he died in 1825.

Upon Cristobal's death, the family moved from Mission San Juan Capistrano to the pueblo in Los Angeles to be closer to the rancho while Cristobal's eldest son, Manuel, and his brothers constructed homes on the property. After the family moved onto the rancho, Manuel thought it a good idea to petition the Mexican government to officially recognize the land grant given by Spain. Since Mexico's independence, many of these grants had gone back to the government, and Manuel wanted to make sure that didn't happen with his family's legacy. During the survey, the Sepulveda heirs claimed the portion of land they had been working and asked Mexico to cede it to their family; the Dominguezes protested, but in 1827, the land was divided up, with 31,629 acres of the original land grant going to the Sepulvedas. This became Rancho Palos Verdes. Manuel met and married Maria de Cota that same year and, in 1828, was elected to the Los Angeles *Cabildo*, or city council; four years later, he became mayor. He served as the Pueblo de Los Angeles's representative in Alta California's capital of Monterey until 1834, when he was selected by the governor to be prefect of Southern Alta California.

During the Mexican-American War, the city of Los Angeles capitulated, and American forces occupied the town with a small force of troops as a garrison. In late September 1864, Mexican militia laid siege to the city, forcing America to respond. U.S. troops arrived in the port of San Pedro and advanced north, confident that their 285 marines would put down the militia; however, the adobe at Rancho San Pedro stood in their way. Mexican general Jose Flores had hidden a stockpile of weapons after the surrender of Los Angeles, and these would be used to defend against the

expected American troops. One of these weapons was buried in the garden of Inocencia Reyes. When the Mexican militia arrived at her adobe, she pointed out where the old brass four-pounder cannon had been buried, and it was loaded up and moved to the small hilltop at the Rancho San Pedro, where the Mexicans waited for the marines to arrive.

On October 8, the poorly armed American troops arrived at the outskirts of the Dominguez Rancho expecting an easy time against any opposition. The marines, however, were poorly equipped, had no horses or heavy guns and were no match for the ninety militiamen blocking their way on the high ground. The cannon and the muskets of the Mexican horsemen held off the marines until their commander realized that it was a lost cause and retreated back to his ship in the harbor. The entire battle lasted less than an hour with no militia harmed, four marines killed and six wounded in what would become known as the "Battle of the Old Woman's Gun."

In 1848, the Treaty of Guadalupe Hidalgo was signed, thus ending the war between Mexico and the United States. Delegates were elected to attend the First Constitutional Convention in California, and Manuel Dominguez was one of the seven sent from Los Angeles and became one of the signatories of California's constitution.

For the third time, Rancho San Pedro needed to be officially recognized as belonging to the Dominguez family, this time under United States law. It took almost seven years for the land patent to be granted, but eventually President Buchanan granted ownership of the property to Manuel and his family on December 18, 1858. It had been seventy-five years since the original land grant, but now it became officially owned by the Dominguezes. Due to turmoil in the state itself, the bitter rivalry with the Sepulvedas and confusion over several surveys, the original parcel was reduced from seventy-five thousand acres to a mere twenty-five thousand granted under United States law, a substantial loss in acreage; on the plus side, the land granted could not be taken away from the family ever again.

When Manuel passed away in 1882, his wife took control until she passed a year later. The rancho was then divided up among his six children, all daughters, three of whom married into some of the most prominent families in the area, the Watson, Carson and Del Amo clans. In 1910, Gregorio Del Amo—the husband of Susana Dominguez and an aviation enthusiast— arranged for the first ever International Aviation Meet to be held at Rancho San Pedro. Dominguez Field, as it was called, would be the perfect spot. Organizers invited pilots from around the world to show off their biplanes, monoplanes, balloons and blimps (dirigibles) for a span of ten days in early

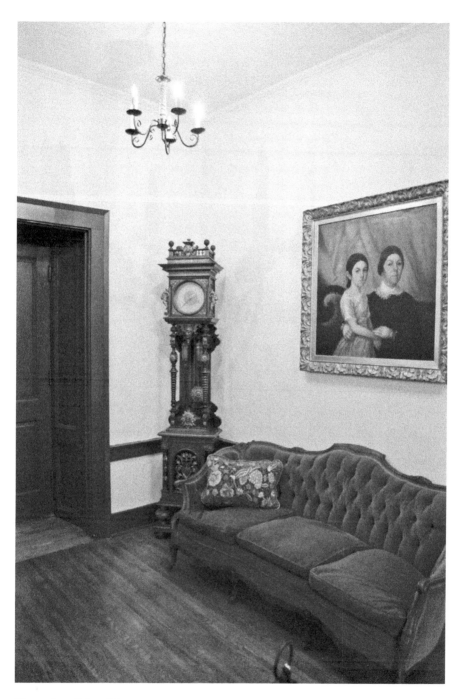

The parlor of the adobe.

The Claretian Retirement Home and School. Gregorio and Susana Del Amo are buried under the chapel's altar.

January. Some of aviation's earliest pioneers showed up, including Glenn Curtis and William Boeing. William Randolph Hearst got his first ride in an airplane at this event. By all accounts, it was a great success.

The members of the Dominguez family had always been devout Catholics and were always generous in their tithes to the church. They had made large donations to help with the construction of the Los Angeles Cathedral, Saint Vibiana's. Then, in 1922, the two remaining daughters donated seventeen acres of the rancho land to the Claretian missionaries. The Claretians used the adobe house as a school and seminary and later built a retirement home for the priests. In recognition of all that the family had done and their devotion to the order, Gregorio and Susana Del Amo were buried in a special crypt placed beneath the altar of the chapel located in the retirement home.

After all this time, with all the changes that the world and the United States have seen, Rancho San Pedro still lives today. The City of Los Angeles has assumed much of it, including the port and a strip of land connecting the harbor to the city proper, but through all of it, the Dominguez family had the foresight to keep much of it in the family. The original seventy-five thousand acres are now broken up into the cities of Carson, Torrance,

Gardena, Wilmington and Dominguez; however, one can still see the original adobe ranch house at the Rancho Dominguez Adobe Museum. The house itself was placed on the California Historic Register as Landmark #152 and in 1976 was added to the National Register of Historic Places. It is a link to our state heritage and harkens back to California's Spanish, Mexican and American heritage. It is also still home to spirits that have never left.

With the history of the rancho and the battle that was fought at the site, one would think it would be rife with spirits. This may be the case, and there is at least one spirit that has been reported by many people who have visited this wonderful little museum. It would seem that at one time in the history of the adobe house, sometime around 1865, it was used as a wayfarers' stop. One southern gentleman, it seems, ran afoul of some Yankees who didn't take kindly to his insults regarding the Union or the president. One of the Yanks drew a pistol, buffaloed the man and then robbed and hanged the poor southerner. This man is now seen quite often wandering the grounds of Rancho Dominguez, as well as inside the house. The most common place for this poor soul to be seen is near the corner of Del Amo Boulevard and Wilmington Avenue. Those who have spotted him report that he looks as if he is confused or lost, and one witness is quoted as saying, "It's as if he can't seem to understand what has happened to him and is looking for answers." Whoever this poor man is, let us hope he finds peace.

The priests who reside at the retirement home on the property have reported seeing a spirit they believe to be that of Manuel Dominguez himself. Manuel loved his garden and enjoyed taking care of it and making things grow. It was one of his great pleasures to stroll through the flowers and shrubs on warm summer nights to take in the serenity of the place. The spirit that the priests see is that of a man dressed as Manuel would have been from the early 1800s, and this ghost walks slowly through the garden with a slight, pleasant smile on his face. He will slowly stroll along and then simply vanish from sight. If one of the watching priests tries to approach, the spirit will glance over, give a grin and nod and then disappear from view. It would seem that Manuel Dominguez might still be enjoying his garden, even in death.

Over the years the Dominguez Adobe has allowed paranormal investigators into the house, what they have found are some of the normal occurences one might find in a haunted location. Cold spots, orbs, strange sounds and even the aroma of cooking have been reported within the confined spaces of the adobe. Streaks of light have also been reported darting about the

A report from the adobe said the eyes of these dolls will follow visitors.

home; these lights are generally believed to be the spirits of the Dominguez children who have died in the house, but no one is certain of this.

Psychics who have investigated here have reported feeling the presence of what they describe as "a heavy, male, dominating presence," which seems to linger near the fireplace. Some assume that it is Juan himself or perhaps Cristobal who is present; however, because Juan never actually set foot on his land grant and Cristobal only rarely, most believe this spirit to be Manuel. With his frequent visits to the garden, it shouldn't be a surprise that he would be checking up on the adobe he built for his bride and his family.

Even though the Battle of the Old Woman's Gun—or, more formally, the Battle of Rancho Dominguez—was a short and, thankfully, casualty-light battle, it seems to have had an impact on the area itself. Many ghost hunters claim to hear the sounds of war coming from the hillside where the battle was fought, as well as the sound of men screaming in pain. This may well be from the power of suggestion, as we are all taught that war can be a powerful progenitor of misery. Along with the sounds, the aromas of dust from the field of battle; tanned animal hides, assumed to come from the cloaks and coverings of the troops; and cooking fires and food have been reported from the area where the skirmish took place.

The Rancho San Pedro (now known as the Dominguez Rancho) was once the central hub of one of the largest and most historic land grants in the history of California. It is the proof of the greatness of each nation that controlled its borders and the faith each in turn had in the Dominguez family to oversee the land. It is also a testament to the fortitude, courage and brilliance of a family to endure even to this day. One cannot know the true history of Los Angeles without knowledge of the Dominguez family.

Chapter 3

THE BANNING MANSION

Admiral Phineas Banning or General Phineas Banning—either one will do when talking about the father of San Pedro. Banning came to the small town of Los Angeles in 1851 to escape a life of boredom and to seek out adventure in the great untamed West. What he found when he arrived was a small port town ripe for the plucking, and he decided that he would be the one to do that plucking. He quickly found employment as a clerk on the tiny pier owned by Spanish Don Jose Antonio Sepulveda. The port at that time was nothing more than a few clapboard shacks and hastily thrown together wooden piers—all that was really needed to handle the few ships coming into port. Banning, however, saw the potential of the area and knew that one day it could and would be much more.

Sepulveda not only ran the pier, but he also owned a stage line that served between the port and the town of Los Angeles twenty-six miles north. Banning knew that if he wanted to form connections with the right people, he would have to be able to get to Los Angeles, so he worked his way up to become a driver on one of the wagons Sepulveda owned. Banning saved all his money, spending only what was needed to stay alive, and put the rest away in an effort to buy his own wagon and team. It didn't take long before Banning started running his own wagons. To save money, he began driving long haul loads himself across the California and Arizona desert, which was much more profitable than the short runs up to Los Angeles.

Slowly, his business grew until he was finally able to hire employees. He even took on a partner, Harris Newmark, and expanded his routes

The Banning house.

into the states of Nevada and Utah, going all the way to Salt Lake City. When Banning heard that the army was planning on setting up a fort in the mountains north of Los Angeles, he quickly brokered a deal with the government to be the fort's main supplier. This required him to construct a road to the complex, and by the time Fort Tejon opened, his wagons were there waiting to deliver the supplies.

It was while Banning was overseeing the road's construction that he met and fell in love with Rebecca Sanford. The couple would have eight children together; however, only three would survive, all sons, and Rebecca would later die in childbirth along with their child. This tragedy sent Banning into a long stretch of depression, but as he had his three boys to raise, he carried on as best he could.

Banning had always known that the small port of Rancho San Pedro could one day be transformed into a world port. To this end, he dredged the shallow harbor and built a canal into the town of Wilmington, where he had built his home. This canal allowed for more ships to dock and made unloading cargo easier for transporting to the town of Los Angeles. He named Wilmington after his hometown in Delaware. Once the dredging was complete, Phineas Banning petitioned the federal government to certify the port. This would allow it to receive money for upgrades, maintenance and essentials that every port requires; without it, Banning and the investors would have to pay for such needs themselves. It would take the feds another thirteen years to see the port's potential, but Banning wasn't going to wait. Successfully promoting the port to companies around the country and elsewhere, it took only two years before the first international vessel anchored and unloaded its cargo to head to Los Angeles. The grateful townsfolk dubbed Phineas Banning the "port admiral," and Banning enjoyed the title so much that he insisted everyone use the moniker when addressing him.

When the Civil War broke out, Banning and his partner, B.D. Wilson, both strong patriots, began to worry about the large Confederate-leaning population in and around Los Angeles. They both decided that to protect their investments in the port, they would sell, for one dollar each, a plot of land to the government to be used as a garrison. The army agreed, and Fort Drum (later just Drum Barracks) was established. This fort became one of the best-equipped bases and housed one of the most elite fighting units in the army at that time: the California Column. Drum Barracks is also said to be quite haunted (see Chapter 4).

Once the war was over, the army maintained the fort until 1871, when it was decided the cost of maintaining the camp was more than it was

worth. The U.S. Army sold the land back to Banning and Wilson for one dollar each—the same amount it purchased it for—and auctioned off the buildings. This worked out well for Banning because in 1864 he had built a beautiful twenty-three-room Greek Revival mansion on the northern edge of the camp, and he could now incorporate the land into his estate. Banning had met and married wealthy land heiress Mary Hollister in 1870, and he was looking forward to having a woman in the house again, and possibly even more children. Mary would grant him his wish when she gave Phineas two beautiful daughters. A third child was born but did not survive—another blow to Banning, who was a devoted father.

Because Banning had been gracious enough to, in essence, donate the land for Drum Barracks, the army, in a show of gratitude, bestowed on him the title of honorary brigadier general of the California First Brigade. Banning had always like the sound of admiral before his name, but now that his title was official (albeit honorary), Banning insisted from that day forward on being addressed as General Phineas Banning. Everyone knew that his rank had no authority, but they were amused at his boasts and always humored him with the title.

Over the intervening years, Banning worked diligently to grow the burgeoning Los Angeles Harbor into one of the premier international ports in the United States. He brought the first railroad to the area—the Los Angeles to San Pedro Line, which he eventually sold to the Southern Pacific Railroad in 1873—and built the first breakwater in the San Pedro Harbor, which made the port considerably safer for docking vessels. As a state senator, he was a champion for the growing city of Los Angeles and was instrumental in building it into the world trade center it is today. The parties he threw at his mansion (what he called regales) were the talk of the state not only for their guest list but for their flamboyance as well.

As the 1870s came to a close, Phineas Banning had begun to slow down. He still managed a few smaller businesses near his home in Wilmington but otherwise left the larger part of the holdings in his sons' hands. Banning would still take trips when needed, but his health was failing due to liver and kidney disease, along with complications from being hit by a buggy while on a trip to San Francisco. It was on another trip to the City by the Bay in 1885 that Phineas Banning checked into the Occidental Hotel but never checked out; he died at the age of fifty-four and was brought home to Los Angeles and buried at the Angeles-Rosedale Cemetery.

Banning's sons continued on with the family business after their father passed, and the youngest son, Hancock, continued to live in the mansion

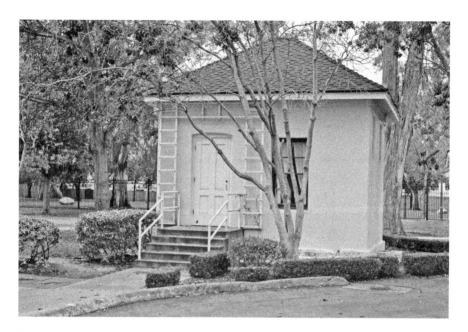

The Banning house kitchen/smokehouse.

until 1894, when he passed away. The mansion would then see various family members reside there until the City of Los Angeles bought the house and property in 1925. The city maintains the complex as a museum with the schoolhouse, barn and mansion open to guests.

Banning's death was by no means the last we heard from the General. It would seem that Phineas has decided he was just not ready to abandon his holdings or the city he named. Today, many a visitor to the mansion and the outbuildings has caught a glimpse of the Admiral wandering around the grounds. The barn is part of the tour of the museum, and many visitors have reported what they describe as "a man dressed in a Victorian suit and tie walking around and checking the carriages." They have asked about the man and whether he is playing Banning. The guests are amazed when they find out that there is no one employed at the museum who fits that description. This same gentleman has made appearances in the old schoolhouse as well; however, those sightings are rare.

Banning has also been frequently spotted in the mansion. The reports state that guests have seen General Banning bent over a plotting table surrounded by other officers. It appears as if the General is poring over a map that is seen lying on the table and planning battle strategy with his subordinates. This is an event that could never have occurred in real life, as his rank was

strictly honorary with no attached authority; however, that does not mean that what people are seeing is not the image that Banning himself kept deep in his subconscious and is transposing into the ether after death.

Phantom smells are another common occurrence within the mansion. Many tour guests have reported the odor of cigar smoke in and around the den area. This is the room where the men would gather after dinner to smoke, drink brandy and talk about the politics of the day, their past conquests and whatever braggadocio they could come up with to impress one another. The parlor is another area where smells occur; here, however, it is always that of perfume. Like the den, the parlor was the place to which the ladies would retire when the men went off to smoke their cigars. Here, the ladies would converse about the accomplishments of their children, the latest in fashion trends, recipes and how they must deal with their oldest children: their husbands. In both of these rooms, the aroma is fleeting but distinct nonetheless.

The second floor is where the bedrooms are located; here there have been numerous reports of the sound of children playing. Phineas had to witness the death of six of his children: five with Rebecca and one with his second wife, Mary. Banning was a devoted family man and loved all of his children deeply. It is indeed possible that the sounds of children in the upstairs area are from those children the Bannings lost in life. Who can say what the love of a father or mother could bring in the afterlife? If Phineas and one or both of his wives are still present at the mansion today, is it such a stretch of the imagination that they would bring their beloved children with them? Due to so many of Banning's children dying in the home, I can think of no other explanation. There is, however, one other possible reason for the sound, as the third floor has had reports of activity involving children as well.

The third floor is off limits to museum tour guests and is now used for docents, museum seamstresses and the museum's various storage needs. At one time, however, this was the servants' quarters. Many of the young women who worked in the home at the time had children of their own, and those kids lived in the house as well. Some of these kids worked in the laundry when not in school, and it is not known how many may have died while living in the mansion. The sound of children running along the upper hall has been frequent, as has the sound of their laughter. There is also the heartbreaking wail of a crying baby that is heard now and again emanating from the third floor. Whispering has been heard coming from the upper floor by some of the docents when there is no one else in the house, and these voices are always female. It is speculated that these are the voices of

those young ladies who have decided to remain in the home after death because even though their work at the mansion was hard, it was a better living than they would have had otherwise.

The small schoolhouse next to the main building is now used as the tour office and gift shop. The structure was built for the Banning children and the children of the live-in servants of the family. While in school, the kids of both the wealthy and poor were treated as equals. Maybe that is why the sound of children playing and having fun can still be heard in this area.

Long after the Banning mansion was built, the area surrounding the house grew into a thriving suburb of the city of Los Angeles. Many businesses went up along the main roads, and single-family homes became dense around these. Today, these same homes surround the park in which the mansion sits, and just about all the residents have tales involving the haunts on the grounds of the old estate. Many of these stories revolve around hearing what is described as "many horses neighing and stomping about," even though no horses are ever seen. The clatter of wagon wheels and the echo of many men talking and laughing most often accompany the sound of these horses. No matter how many times this phenomenon is heard, no one has ever actually seen anything under the streetlights in and around the park.

The only one of three barns that remains at the Banning house.

Other reports from the homeowners in the area are of seeing lights moving around inside the home even though the museum has been closed for hours. There have been times when teens and young adults have actually gone up to the windows at night to try to find out where these phantom lights are coming from, but every time they have tried, the lights go out before anything can be seen. There have been other reports about a woman walking the balcony as if deep in thought or perhaps searching for something or someone. Still other reports from the neighbors have told of hearing the sound of laughter, music and gaiety, as if one of Phineas Banning's famed "regales" were in progress. Lights have been reported at the same time that these parties were happening; however, any time someone would approach the mansion to investigate, all lights and sounds would simply stop, and the night would again be filled with only the sounds of the city.

The docents who work at the museum insist that the mansion and property are not in the least haunted. But so many reports of the paranormal have come from the residents of the surrounding homes and the tour guests alike that one cannot simply dismiss the tales out of hand. The mansion is beautiful in all its Victorian splendor, and the gardens of the home are a must-see, so if you are in the area, please stop in and say hello to the spirits that may still reside at this piece of San Pedro history.

Chapter 4

DRUM BARRACKS
CIVIL WAR MUSEUM

In the heart of Wilmington, California, stands one of the best examples of how the Civil War was fought on the West Coast of the United States. Far from the worst of the fighting, the war was still a constant threat, and Fort Drum was the key to keeping California safe from Johnny Reb. Today, it is one of the most haunted sites in the area.

At the time the war started, the Port of Los Angeles (or New San Pedro, as it was called) was a burgeoning shipping stop and was considered vital in the chain of supply for goods passing through the docks on their way to the war effort. Fort Tejon was the primary garrison but was so far away that if an attack came, it would be long over before any help could arrive. The army set up a camp in present-day Culver City, but at eighteen miles away, that, too, was deemed too distant for adequate protection.

Enter Phineas Banning.

Banning and his partner, Benjamin D. Wilson, were both staunch nationalists, and both had serious misgivings about the large Confederate population that resided in Los Angeles. Banning and Wilson sent a letter to the White House with their concerns and offered to sell sixty acres of land near the port to the government for two dollars—one dollar for each of them—for the sole purpose of setting up a fort for the defense of the area. The government agreed, and work began on Camp San Pedro almost immediately. The cost of the camp came in at a cool $1 million, which in those days was an exorbitant price even for the protection of one of our country's most precious ports. The troops that came to Camp San Pedro

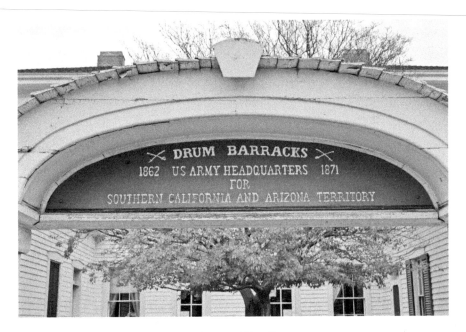

One of the only Civil War museums left on the West Coast.

would boast to their comrades back east about how the barracks were the best they had ever seen and how the hospital was one of the best, if not the best, in all of the United States Army.

When the camp finally opened, Phineas Banning thought it would be a good idea to honor the then assistant adjutant general of the army, Colonel Richard Coulter Drum. The recommendation was approved, and the camp's name was officially changed. Over the next few years, the papers coming from the camp were simply stamped "Drum Barracks," and hence the army changed the name to reflect this "official" name change.

Drum Barracks became home to the now famous California Column, which was commanded by Colonel James Henry Carleton. This unit was perhaps the best-equipped and best-trained unit in the army and was known as one of the best fighting units because of this. The California Column fought the westernmost battle of the Civil War when it marched out to retake eastern Arizona and parts of New Mexico at the Battle of Picacho Pass. Then, in 1864, the column was again called up to guard the coves and harbors of Catalina Island to deter any Confederate ships that might try to use them as a staging base to raid the ore carriers transporting silver from the rich Comstock Lode. The Fourth California Infantry set up its garrison at Isthmus Cove for this purpose; today, the old buildings are used

by the Isthmus Yacht Club and are the oldest structures on the island. The buildings are haunted by troops that were stationed at the garrison, and many of the locals on the island have stories they like to tell about the spirits that reside there.

With the war over, life at Drum Barracks became routine, with day-to-day drills performed by those stationed there, while others would simply pass through on their way to what was being called the Indian Wars. The fort was now also the main supply and weapons distribution center for the entire West Coast.

Drum Barracks is registered as a National Historic Site.

Just after the war, the army had the idea to start using camels instead of horses in the western desert. The camels were based at Drum Barracks for two years before the experiment was abandoned as a failure, but in that time, the animals completely devastated the surrounding grasslands. It took years for the area to recover.

The War Department—no longer seeing a need for so large a presence and struggling with the huge cost of maintenance, manpower and the associated expenditures—finally decided to close Drum Barracks shortly after the camels left. The land was given back to Banning and Wilson for the original two dollars, and the structures were auctioned off, with many of them being sold to the two businessmen. Wilson decided to create an institution for higher learning, and his Methodist College became so successful that he needed more room and moved to Los Angeles. Banning purchased most of the land, and he had no intention of moving. He decided to build a grand mansion on the northern end of the property, and this became his showpiece. His parties became famous for their grandeur as well as their guest lists. His mansion is said to be quite haunted as well (see Chapter 3).

Over the years, the fort and surrounding land were sold off piecemeal, with various oil companies and land-use developers buying up most of the property. In 1927, the remaining structures and land were designated a historic monument, and in 1931, they were designated California Historic Landmark #169. Even with these prestigious designations, no one stepped forward to offer significant protection to the area, and over the years, the property became overgrown and the wooden structures began to deteriorate until there was virtually nothing left. By 1962, all that remained of the old fort was a single cement powder magazine and the now dilapidated junior officers' quarters.

Recognizing the value of the land for residential development, real estate investors began lobbying the City of Los Angeles to abandon the property and allow them to build homes on the historic site. The city was seriously considering washing its hands of the old fort when the Society for the Preservation of Drum Barracks was formed. This organization was determined to save as much of the fort as possible, but it would take another five years to get anything accomplished, and in that time, the two structures, as well as the land, would continue to be ravaged by the elements. In 1967, the State of California stepped in; it purchased the property for the sole intent of establishing a Civil War museum.

The state selected the Society for the Preservation of Drum Barracks as the caretakers of the property, and it was their responsibility to restore,

maintain and operate the museum. It was during the restoration that many of the laborers and museum personnel noticed that there were strange things occurring while the work progressed. It took many years for the junior officers' quarters to be transformed into the fine museum we see today, but in 1986, the State of California turned the museum and property over to the City of Los Angeles with the stipulation that it would always remain as a Civil War education center.

Even though many of the workers had noticed what some called "mystical happenings" while the building was being transformed into a museum, the directors didn't want it known that Drum Barracks was haunted. Maybe because of its war history or maybe because people just think that old military buildings should be haunted, many museum guests would ask about activity; the answer was always the same: no. It didn't take long before the truth came out, however. It would seem that no matter how adamant the docents were in dismissing the spirits, the spirits were just as unwavering in making sure that visitors knew they were there.

A dense residential community grew up around Drum Barracks, and many of the residents already knew that something odd was afoot in the old officers' quarters. The children in the area had always assumed that the place was haunted, but many of the adults knew that it was as well. There have been many reports of the sound of horses neighing and clopping around in the field behind the barracks building. The sound of chains has been heard, along with the distinct din of soldiers talking, moving about and readying for muster. Witnesses say that it sounds as if the place is still an active military base and that the men are getting ready to move out. The sound usually lasts only a minute or two before fading away into the night. With these reports coming from the nearby homeowners, it was not long before the cat was out of the bag regarding the ghosts of Drum Barracks.

Over the years, reports have come from docents and visitors regarding phantom smells within the museum. Cigar smoke seems to be the most prevalent, with many people catching a whiff in what was once the sitting room for the young officers at the camp. The smell has been so strong at times that children, as well as those more sensitive to smoke, have been forced to leave the room. Being a museum, smoking is strictly prohibited, so the odor is not coming from anyone on the tour.

Perfume is another aroma commonly perceived at Drum Barracks. Now, women do go on the tours, of course, and many have been known to wear scents; however, after about ten or fifteen minutes, people usually become

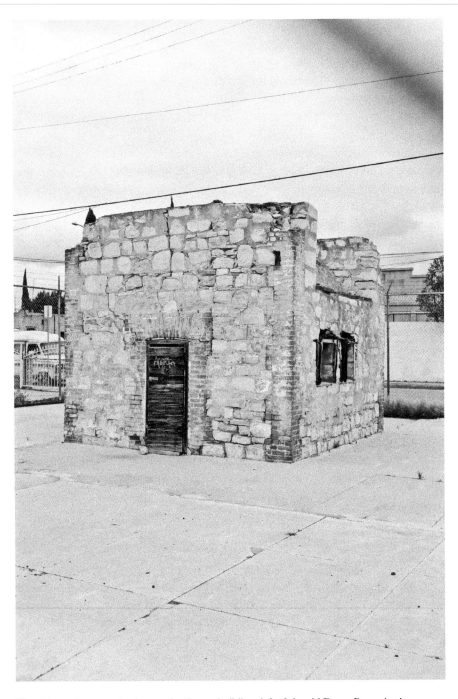

The old powder magazine is one of only two buildings left of the old Drum Barracks site.

aware of and used to those scents and they become familiar to that tour group. When a new, overpowering aroma suddenly enters the room, it is hard not to notice. This happens quite often, and the aromas of violet and lavender are usually quite strong but also very short in duration. Docents have also reported catching the smell of both the perfume and tobacco smoke while they have been locking up for the night and while no one else is left in the building.

One of the other things that many of the docents report has to do with the door locks and light switches. The docents are usually the last to leave the museum at night, and it is their job to turn off the lights, as well as shut and lock many of the interior doors. Many of the docents complain about how they will go about this task only to find that when they finally lock the front door and are ready to leave, they will glance up and notice a light still lit on the second floor. They will then go back in and find many of the doors they had just locked open and lights left on that they are sure they had turned off. This can sometimes happen two or three times before the spirits allow them to finally go home for the night.

Another strange tale involves a possible child spirit that resides in the old barracks. Psychics have taken the tour at the museum, and many of them have picked up on a young boy whom they believe may have died at the camp hospital after it was turned over to civilian authority. They believe that this youth from the 1880s may be the cause of one of the most reported occurences at the Drum Barracks. Both docents and guests have heard the sound of a ball bouncing down the stairway and then rolling down the hallway toward them. Upon looking, however, no ball is ever found, nor is there any sign of anyone who could have either rolled or retrieved this ball. Many believe that this child is simply looking for someone to play with him but always runs when adults come forth.

Noises and odors are not the only extraordinary things that occur at Drum Barracks. People have also seen things that they can't explain. Over the years, the spirit of a beautiful woman has been seen wandering the halls of the old officers' quarters. This apparition is thought to be the same spirit that is responsible for the violet and lavender perfume that is smelled in the halls and rooms at other times. She is always seen dressed in a formal hoop skirt and is often carrying a paper fan in her left hand. The psychics who have visited the museum can't seem to agree on who this lovely spirit may be; some say that it is simply the girlfriend of one of the dashing young officers who was stationed at Drum Barracks, while others claim it is the wife of the camp's first commanding officer, Colonel Curtis.

Whoever she may be, she is seen often enough that she has been given a name. The docents and volunteers at the museum call her Maria and have become quite fond of her.

Maria is not the only spirit to be spotted within the halls of the old barracks. Apparitions have been observed wandering around the rooms and hallways and are always wearing the uniform of the United States cavalry from the 1880s. One of these spirits is often glimpsed walking as if he is confused or injured. He seems to stumble often and has even been known to lean into the walls as if for support. It is believed by the psychics that this soldier is perhaps one of those who was injured in battle and may have died at the hospital. They think his actions may be tied to his dedication to return to his unit and lead his men even after death. Whenever this poor specter is approached, he will simply smile and vanish from view.

It is also believed that Colonel Curtis himself has remained at the camp, perhaps to make sure that Drum is well taken care of. His spirit is most often seen in the parlor room but has also been glimpsed in every room in the old officers' quarters. Many believe that his strong ties as the camp's first commander and the officer in charge of making Camp Drum the "finest camp" in the U.S. Cavalry have kept his spirit from passing on.

Drum Barracks is one of the most haunted sites in old San Pedro.

His presence may also lend credence to those psychics who say Maria is Colonel Curtis's wife; it could be her devotion to her husband that keeps her close even after death.

While doing research for this book, my wife, Terri, and I decided to take the tour. Although they do not allow photographs within the museum, they did not have a problem with me using my digital recorder to document the history being told on the tour. Once I got home and began listening to the recording, I caught the sound of zydeco music. I thought this was odd and sent the recording to the museum staff for clarification. They told me that it indeed sounded like the instrument they had on the property, but theirs was not in working order, and even if it was, there was no one who knew how to play the thing. We all heard the same thing: "Silent Night" was playing, but as it was July when we took the tour and no one could play the broken instrument, we have no answer for where the music originated from.

Most people don't know that the Civil War was felt this far west or that California was a pivotal link in the protection and support of the battles back east and south. Drum Barracks helped prevent the South from obtaining much-needed materiel and supplies to carry out its war effort and denied the Confederates much-needed Pacific ports. This wonderful museum is a place where today's youth can come and learn about the deadliest war in our country's history and meet the spirits of those long-lost heroes of our nation, both North and South.

Chapter 5

POINT FERMIN LIGHTHOUSE

High atop the cliffs at the tip of Point Fermin sits a guardian, a sentinel watching the horizon for its charges and longing for the days of old when its beacon would safely pilot the wayfarers home—when its light was the only guide against the rocks of the coast and the old building still had a purpose. The Point Fermin Lighthouse sits now as just a memory, a place for schoolchildren to take a field trip and for history buffs to gaze at while dreaming about a past long gone. There are spirits here as well, and they, too, keep their memories and long to have a purpose once again.

In 1854, Phineas Banning, with the help and support of local businessmen and entrepreneurs, petitioned the U.S. Lighthouse Board to erect a beacon high atop Point Fermin as a way of helping ships into port. The Palos Verdes Peninsula had always been a dangerous, rocky place for ships, with many of them being run aground and destroyed by the pounding surf. As Banning and the others had hoped to turn San Pedro into an international trading port, a lighthouse to guide the vessels into the harbor was a must. The federal government agreed to the construction and funding; however, land disputes and the inevitable government red tape delayed the building of the light until 1874.

By the time construction on the Point Fermin structure began, the Lighthouse Board had already approved five other beacons. Draftsman Paul J. Pelz had designed what he called the Stick-style lighthouse, and it was decided to use this design for the six new coastal buildings. Only three of the six structures built between 1873 and 1874 remain: the Hereford Light in

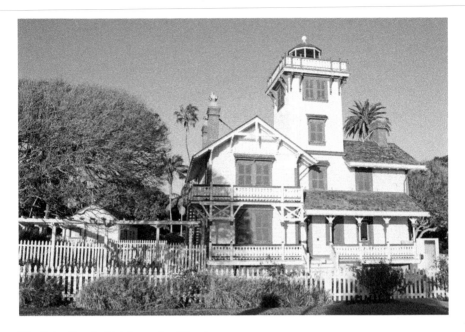

The Point Fermin Lighthouse in all its glory.

New Jersey, the East Brothers in San Francisco and the one at Point Fermin. This simple Victorian-style structure can be recognized by its gabled roofs, decorative cross beams and curved porch railings. The light and upkeep of the house would be completely under the jurisdiction of the U.S. Lighthouse Board, and its employees, called lighthouse keepers, would be hired and regulated by the U.S. Department of the Treasury. It was the keeper's job to make sure the beacon was lit, the lens was cleaned and maintained and the general upkeep and care of the structures and grounds were tended to.

The Lighthouse Board was one of the first organizations in the United States that didn't discriminate between men and women; it picked whichever person, regardless of sex, it felt was the best choice for keeping the ships and property safe. As such, it is not really a surprise that the first keepers at Point Fermin were women. Mary and Ella Smith were hired as the first keepers of the Point Fermin Lighthouse, and the sisters were more than qualified for the job. They came from a long line of lighthouse keepers, and their brother was even a Washington Territory customs officer who most likely helped in getting the women their jobs at Point Fermin. However the two sisters came to be the keepers of the light, they moved down from the Ediz Hook Lighthouse and were the ones to first hold a flame to ignite the beacon inside the fourth-order Fresnel lens on December 15, 1874.

The Smith sisters held the position as keepers for eight years, until they decided that the isolation of the area was too much and resigned and tried to find husbands. Shortly after the sisters moved out, retired sea captain George Shaw replaced them. Shaw was quite happy to accept the keeper's job, as it kept him close to his beloved ocean, and he quickly moved into the house, bringing his wife and daughter with him. In 1884, the U.S. Lighthouse Service required all of its keepers to wear uniforms, and Shaw was the first at Point Fermin to do so; women were exempt from having to wear them. Another requirement of the service was for the lighthouse keepers to not only allow the public to visit the lighthouses but to encourage it as well. Visiting the Point Fermin Light became a popular activity for the locals, who would come to the point for picnicking, parties or just for the view. Captain Shaw was only too happy to give them tours of his lighthouse. The Red Car was always a popular ride, and it alone brought many people from Los Angeles to the point. As the 1800s came to a close and the automobile entered the scene, it brought even more visitors to the area. By 1901, Shaw's daughter had moved away and his wife had passed, and the captain was alone at Point Fermin. He now welcomed the tours and the people even more and became almost a local celebrity for his wit and humor, as well as his welcoming ways. He was

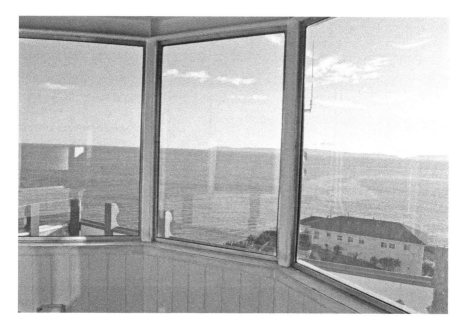

The view from the lantern room.

said to treat all who came to his lighthouse as family and invited everyone back for a visit.

Shaw had always been a man who loved people and had many friends. While living at Point Fermin, he and his wife threw many parties. Even after his wife died, the captain continued the reveling until he finally moved out of the lighthouse in 1904. Irby H. Engels, who had an uneventful career as keeper until 1917, replaced Shaw, and then when Engels retired, the Austin family moved into the lighthouse with their seven children. William Austin had served as keeper at both the Point Arena and Point Conception Lighthouses before he and his wife, Martha, decided to move south to the warmer climate of Point Fermin. When the Austins moved in, it marked the first time that the sound of children was heard in the house, and it wasn't long before Martha and William added an eighth child, a son, to the happy brood. When both William and Martha passed away in 1925, their two oldest daughters accepted the responsibility as keepers, but that position would last for only two years; in 1927, Thelma and Juanita Austin became the last lighthouse keepers when the management of the beacon was turned over to the City of Los Angeles.

When the city took over control of the light, it was electrified, and the city turned the house into a dwelling for a park superintendent. As payment to the city for the dwelling, all this person had to do was keep an eye on the light and make sure it was functioning; otherwise, the lighthouse was just his place to live. On December 7, 1941, the Japanese bombed Pearl Harbor, Hawaii, and brought America into World War II. Two days after the attack, blackout orders were given for the entire West Coast as a precaution against further Japanese aggression, and the Point Fermin beacon was extinguished. It would never be lit again.

During the war, the U.S. Navy took control of the lighthouse and used it as a lookout tower to spot enemy ships and planes coming in to attack San Pedro Harbor. It was also used as a signaling station for friendly ships entering or leaving San Pedro and Long Beach naval station. The navy dismantled the light and converted the lantern room into an ugly square room for the sentries; it quickly acquired the nickname of "chicken coop" by those who were stationed there. After the war, the Navy Department again ceded the house and property to the city, but by then, a metal pole with a light attached to it had been placed close atop the bluff as a replacement for the lighthouse itself. The U.S. Coast Guard maintained and operated this light, and with no more need for the beacon and with the tower having been converted, the fate of the Point Fermin Lighthouse

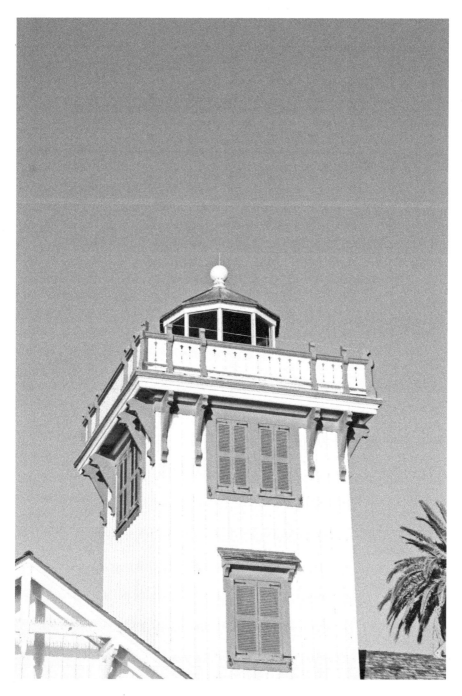

The tower room where footsteps are often heard when there is no one there.

now came into question. The city decided to turn the place into offices and a dwelling for the Parks Department and used the other buildings on the location as storage, equipment maintenance and other uses for the parks. In 1972, the coast guard was thinking about tearing down the entire complex, regardless of what the City of Los Angeles wanted, but a pair of preservation-minded citizens stepped in to save the historic lighthouse from the wrecking ball.

Bill Olesen, a local resident of San Pedro who had been an avid supporter of the lighthouse since the first day he visited it when he was eight years old, recruited the coordinator of the Cabrillo Marine Museum, John Olguin, and together they raised funds, gathered support and diligently began restoration of the lighthouse back to its original configuration and glory. Gone was the "chicken coop," and using the original blueprints, the lantern room was meticulously restored. Unfortunately, the Fresnel lens had been removed sometime in the 1940s and had been missing ever since, so a wooden replica was installed as a replacement. The goal of the two men was to have the lighthouse ready in time for the one-hundred-year anniversary celebration of the light's opening. According to Olesen, "The exterior restoration was completed about fifteen minutes before the centennial celebration."

Before the restoration was completed, Olesen and Olguin had looked far and wide for the missing Fresnel lens without much success. Years later, while the two men were dining in a restaurant talking about the lens, they met someone who knew about a lens that was in an office in Malibu, California. Upon investigating the claim, they found that there was indeed a fourth-order lens on display in a real estate office. After years of negotiation and investigation, it was proven to be the original Fresnel lens missing from Point Fermin. With proof that this was indeed the lens from the lighthouse, the owner at last gave consent to return the Fresnel to the Point Fermin Lighthouse Society. On December 16, 2006, a homecoming celebration was held, and the lens was put in a place of prominence for display to the public.

In 2002, the City of Los Angeles spent $2.6 million to give the old lighthouse some much-needed maintenance and upgrades. A fresh coat of paint was applied both inside and out, a new fire alarm and suppression system was installed and new electrical work, plumbing, air conditioning and period furniture was found and installed. Then, on January 20, 2015, the lighthouse was officially given to the City of Los Angeles under the National Historic Lighthouse Preservation Act, with the Point Fermin Lighthouse and Point Fermin Historical Societies overseeing the upkeep and day-to-day operations.

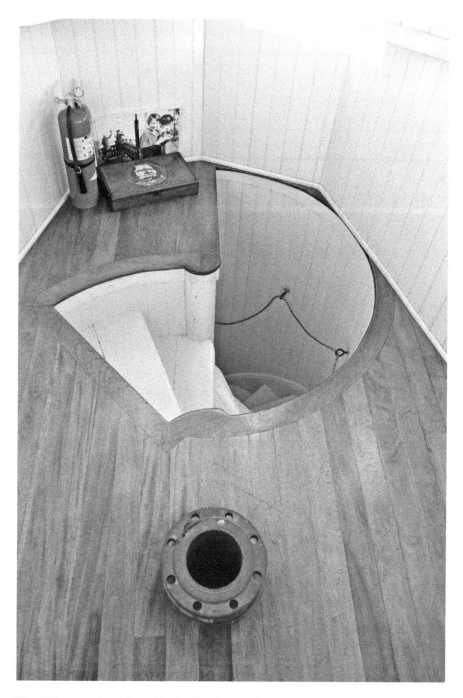

The old lens stand and the ladder leading down to the main house.

Over the years, many stories have been told about the old lighthouse regarding ghosts and paranormal activity. As one can imagine, these tales have been disregarded by the city of Los Angeles, as well as the societies that run the place; however, even those who work for these agencies have let slip reports of ghostly activity. In the 1970s, an employee of the Parks and Recreation Department who resided at the Point Fermin Lighthouse would tell of hearing footsteps atop the tower as he was climbing the stairs. He used to love going to the lantern room to watch the waves and the ocean, especially during storms, and many times during his assents, he would hear someone walking around but would find no one once he reached the top. He also said that the stories of hauntings were so commonplace that he would get visitors at his door at all hours of the day and night asking him about the spirits he was living with. It finally became too much for him, and he had to move out.

The ghost that resides at the Point Fermin Lighthouse is said to be that of William Austin. When his wife, Martha, died in 1925, the loss hit him hard. His children said that he tried to be strong for them, but after only two months, William followed his beloved to the grave. The newspapers at the time reported the cause of death to be a broken heart. This sad tale does not explain, however, why William has not followed Martha in passing. If he was so despondent over his wife's death, why, then, has he decided to remain at the lighthouse? The docents have never actually denied that the Point Fermin Lighthouse is haunted, but when asked, they say that all the tales were started by one of the caretakers many years ago to keep the neighborhood children and curiosity seekers at bay.

Over the years, many visitors at the park have said they have seen a man looking at them from the lantern room and that this gentleman was dressed in period clothing that looked like it was from the 1920s. The museum does not employ actors or require its docents to dress in costume, so there should be no one there who dresses in this manner. Oddly enough, there is also a young woman who is often seen peeking from the curtains at curious onlookers. There is some speculation about who this lady might be, but as she has never been fully glimpsed, no one is even sure what type of clothing she is wearing. Local urban legend says that the woman may be either one of the past keepers or perhaps a suicide victim who has taken up residence inside the old lighthouse.

There are also many reports from outside the lighthouse. Reports are frequent regarding misty apparitions wandering the cliff top near the old beacon. It would seem that there are quite a few spirits from many

The window where one of the spirits is often seen.

different time periods that have decided to remain at Point Fermin for reasons unknown. It is believed that these lost individuals are suicides that are either lost or too afraid to pass on into the next realm.

Another strange tale from the Point has to do with a homeless woman who may or may not have been real. I am speaking of the Point Fermin Cat Lady. Urban legend has it that this woman was taking care of the feral cats at the Point and was rather militant about them. She was obviously not altogether sane, as she believed that the Catholic Church was behind a conspiracy to kill her cats and desecrate the entire area around the Point Fermin Park and Sunken City. She would carry around a jar with a fetus—or so she said—that she believed was her child and said that it was magical and would help bring down the Catholics and save her cats. This cat lady has not been seen for a few years now, and it is believed that she may have passed away. There have been some reports that since her disappearance the cats in the area have begun acting strangely—walking sideways or up on two legs and even dancing around. They have even been known to attack those who try to approach them empty-handed. All the tales about the cat lady of Point Fermin sound a bit "off" to me, but I include it here for you to decide.

Point Fermin Lighthouse is a must-see for anyone who enjoys the lure and folklore of the old beacons. It is a far cry from the round, straight towers

found along the East Coast of the United States. Its grand Victorian style and its homey atmosphere harken back to a simpler time that most of us, even if we don't realize it, long for. If lighthouses aren't your thing, then the view alone is worth the trip.

Chapter 6
POINT FERMIN'S SUNKEN CITY

San Pedro, California, is not simply a port town full of ships, warehouses and fish; it is also an area with some beautiful landscape. One of these areas that is truly breathtaking is Point Fermin at the very end of Gaffey Street atop the rugged cliffs just below old Fort MacArthur. This spot on the coast not only boasts spectacular views of Catalina Island and a vast array of the Pacific Ocean and port views, but on clear days, one can also see most, if not all, of the Channel Islands. It is a beautiful location—and also one of the most haunted in San Pedro.

One of the reasons that this section of San Pedro is so haunted comes from a failed housing development from 1929. In the late 1920s, local developer George Peck envisioned a grand housing scheme of bungalow homes overlooking the mighty Pacific Ocean. He had just finished the project and was selling the upscale cottages in droves when the unthinkable happened: the ocean decided to reclaim the property for itself. It seems that the geologists whom Peck had hired to inspect the soil of the cliffs were either incompetent or just overlooked the bentonite clay soil that made up the bluff's earth. This slippery clay compound, along with the crashing of the waves from the Pacific Ocean pounding the cliff face below, weakened the hill to the point that it could no longer hold up the homes that had been built atop the bluff, and the entire area began to slide into the waters below. Two homes were lost down the hillside, but the other bungalows were all moved to new locations due to the slow decline of the cliffs.

Sunken City atop Point Fermin.

Even though most of the cottages were saved, the infrastructure itself was not. Left behind were all the roadways, sidewalks, sewer and manhole covers, water pipes and everything else that makes up a modern city; even the famous Los Angeles Red Cars were affected when the railroad tracks leading to the bluffs had to be abandoned. The erosion continued for years after the neighborhood was abandoned, and slowly, the entire area took on the look of a post-apocalyptic landscape. The sidewalks and roads inched closer to the cliff face, and many have fallen into the sea over the decades of decay; pipes were exposed; and manholes were raised and the sewers they covered became open, leaving gaping holes in the ground. It is this vision of destruction that has caused this area to become a destination for teens and adventure seekers and for it to, over the years, gain the moniker of the "Sunken City of San Pedro."

Over the years, the lure of this desolate area has drawn people to it not only for the rubble of the Sunken City but for the sheer beauty of the cliffs as well. Unfortunately, most people are oblivious to the real dangers of the place and wander the old streets without really paying attention to the holes, exposed sewer lines, undermined sidewalks and roadways they are traversing, and accidents have been commonplace. In the past, rescue workers have been called to save those careless individuals who have fallen into these

What once was a street is now a raised lookout spot.

copious traps and pitfalls, many with broken bones; broken arms, legs, backs and even necks have all been reported problems with these slapdash victims. Unfortunately, death is also a common outcome for these accidents.

When the drug culture of the 1960s came on the scene, Sunken City became a natural place for the kids to hang out and do their drugs. Still somewhat remote, being up on the bluff behind an active military base, the police patrolled the area only on occasion and rarely left their patrol cars to investigate whether anyone was trespassing. As the '60s progressed into the 1970s, the urban legend of Sunken City had grown into a full-blown myth of hauntings, from the many deaths that had been occurring when drugs, alcohol and dangerous cliff conditions meet to reports of actual sea monsters and mermaids coming ashore on the rocks below. These tales of ghosts and monsters only fueled the allure, and more and more teens and young adults flocked to the area. Sunken City had now become the place in San Pedro to party and get rowdy on Friday and Saturday nights. I must admit that it was one of the places I went often myself.

As the crowd of revelers grew, so did the incidents of injury and death. The number of calls coming in to the L.A. Fire and Rescue Department grew to a point where the city finally had to do something. It was decided that a wrought-iron fence would be installed around the area in an effort

to completely cordon off the location. This had limited effect at first, and it didn't take long for the determined to find ways into the forbidden zone. Holes were dug under the fence, makeshift stairs and ladders were erected and one industrious person even kept bringing a torch to cut and remove the bars from the fence itself. Even though there were plenty of ways to get into the Sunken City, the fence did have the effect that the city had hoped for: the accident rate dropped dramatically. To try and drop it even more, the city stepped up police patrols, began writing tickets for trespassing and began running people off every time they spotted anyone looking like they were trying to find ways into the area. Now, the only people who were still determined to get into Sunken City were those who were trying to commit suicide and those who had a penchant for street art.

This area of San Pedro has always been known as a prime location for the despondent, financially ruined and those who have just given up on life to come and end their existence. The cliffs of Point Fermin both to the north where the park is located and in the area we now know as Sunken City have seen so many suicides that they have even been called Point Death by many of the locals. Even though the area by the park has seen many of these sad individuals with suicidal thoughts, it seems that Sunken City is the place of choice for the majority of jumpers. It is believed that the main reason for this is its more remote location and its relative privacy from prying eyes. Whatever the reasons may be, Sunken City is a magnet for those wishing to end their lives. It is also a prime location for those with thoughts of murder and a place where murderers tend to drop their victims once the deed has been done.

One of the things that Sunken City is also known for today is its vast canvas for street artists. Some people call these talented individuals taggers or graffiti criminals, but what has been showing up on the fallen walls, sidewalks and other once blank areas of destruction is nothing short of art. Granted, some of the things that have been sprayed are nothing more than gang drivel, but those are usually quickly covered by works from those who call themselves street artists, and many of these are truly masterpieces. Like most impromptu artworks and "tag" murals, these paintings and drawings never last for long. Over and over they are covered by another's work, and so on and so forth. No one is quite sure how many coats of paint now cover the walls and roadways of Sunken City, but it has become an area known by many outside Los Angeles, as well as California itself, and it has become a tourist stop for a lot of people visiting the area.

Because of the widespread knowledge of Sunken City outside California and the fact that it has become a tourist spot no matter how much the

The trail leading to the tide pools where many a fatal accident has occurred.

city has tried to dissuade people from going there, a Los Angeles city councilman for the area, led by local residents, has put forth a resolution that would have Sunken City open during the day for visitors, with an automatic gate that would close at dusk. Lawyers were hired to check into the legal liability issues and have come back with a statement that says the potential gains to the City of Los Angeles far outweigh the limited liability that would arise from opening the area. As interest in the location and its street artwork grows and widens, it has and will become harder and harder to keep the public from surveying Sunken City. The Los Angeles police have begun to crack down heavily on trespassing, as well as arresting those caught with drugs such as marijuana or who are obviously drunk. Even though the location will most likely be open for daytime viewing, the police want to make sure people know they are still not allowed inside the fence after nightfall.

As I mentioned previously, this beautiful spot along the coast of the Palos Verdes Peninsula is not just a place for lovers or those looking for the serenity of the sea and its spectacular views; it is also a prime destination for those wanting to end their lives. Over the years, so many suicides have occurred on and around Point Fermin that even the authorities seem to have lost count. The emotions that these lost individuals must be feeling, the depression, fear,

hopelessness, regret and despair, are some of the strongest a human being can feel and may be one of the reasons that this area is so haunted.

Back in 1996, two teenagers, young lovers who wanted to be together in eternity, decided that the only way to accomplish this was to take their own lives together in what they thought was a final act of love. The kids threw themselves over the cliffs at Sunken City and, still hand in hand, died when their bodies hit the rocks below. The story of these tragic teen lovers was told in all the local newspapers and, unfortunately, spurred another teen couple to follow the same path not long after. Since that time, witnesses have reported seeing the ghosts of a young couple walking with their arms entwined along the cliff tops, as well as on the rocks along the waterline. Out of respect for the families, I will not give further details about which couple is seen, but it is nice to know that they are still together, although sad that they have not passed on with each other to a happier plane of existence.

In 2007, no fewer than three people accidentally fell from the cliffs within the fenced area of Sunken City, and at least one of them has remained. There is a young girl who is seen wandering the site and looking around as if lost. Witnesses say that the look on her face is one of confusion and that she appears to glide over the rubble rather than walk over it. Every time she is approached, she gives a startled, worried look and then simply vanishes without a trace, as if she had never been there.

Visitors to Sunken City have reported hearing the sound of footsteps that seem to follow them as they make their way through the apocalyptic ruins, and many have also reported hearing the sound of children's laughter. We do know that a few children have died by accident while trying to walk down the steep pathways while following their parents for a day of exploring the tide pools below. Could these be the children the witnesses are hearing? Others have told of getting the feeling of malevolence around the site. They say it is a sensation of being watched by someone or something that wants to do them harm. The only thing I can say to this is that it possibly comes from some of the murders and murderers that have been investigated over the years by homicide detectives. At least one murderer we know of committed suicide there rather than go to jail for the rest of his life. This happened back in the late 1940s, and it is possible that this killer remains here to this day.

Other people report getting a strong feeling of depression while at Sunken City, some to the point that they feel like throwing themselves from the cliff and must leave before the feeling overwhelms them. This is said to be a feeling people in this area felt long before the bungalows were built or fell into the ocean. Many believe that it was a curse placed on the area by the

The Sunken City landscape.

native Tongva-Gabrieleno tribe as a way of keeping people from their native lands. This feeling of depression is thought to be the driving force behind the huge numbers of suicides that have occurred here. It was even put forth as a reason USC star kicker Mario Danelo, a young, talented football player with a bright NFL career in his future, was found dead at the bottom of the Point Fermin cliffs.

Psychics who have come to this location have said that the area is a vortex between dimensions, that the geologic makeup of the soil mixed with the ocean and its currents imparts so much energy into the atmosphere that it has caused a rip in the fabric between the world of the living and that of the dead. I do not subscribe to this theory, but I include it here for your consideration.

Another strange thing that appears to be happening at Point Fermin is that UFOlogists have reported a very large number of sightings in this area. It has become a gathering spot for local UFO groups to congregate and look for proof of alien existence. There have been many reports of saucers emerging from the Catalina Channel waters, and these same enthusiasts claim that this is proof that the Great Los Angeles Air Raid of 1942, following the sneak attack on Pearl Harbor, was in fact alien ships checking on the readiness of the United States for the coming war. For

those not familiar with this piece of history, on February 24–25, 1942, air raid sirens blared across Los Angeles and the harbor, raid wardens were summoned to their posts and a fierce barrage of .50-caliber machine gun fire and antiaircraft guns exploded into the night sky. When the all clear was finally called, no aircraft were hit or even found to have been in the vicinity as the fusillade was going up. Five people had been killed: three due to traffic collisions and two who had massive heart attacks as a result of the panic. Over 1,400 shells were fired, and the damage they caused to personal property was extensive. The official statement from the U.S. Office of Air Force History attributed the event to a case of "war nerves triggered by weather balloons."

Of course, any time our government mentions the words "weather balloons," the UFO crowd automatically hears "spaceships." UFOlogists point to photographs from that night as proof of extraterrestrial life. They say that the photos clearly show search lights illuminating what appears to be a flying saucer. The photos, however, were highly modified by retouching with a graphic artist before they were published. This was a common practice in the 1940s to improve contrast in black-and-white photographs. A well-respected *Los Angeles Times* reporter stated that the retouched photos, along

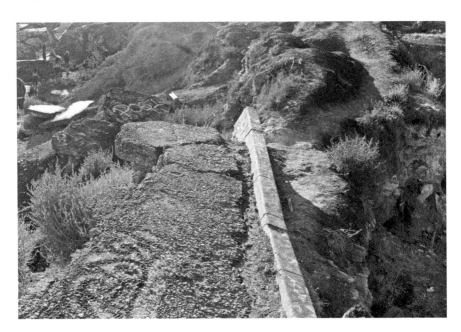

An apocalyptic landscape is all that remains at Sunken City today.

with fake news headlines, were put out, and this is what these enthusiasts are basing their spaceship sightings on. These same photos and clippings were also used in the Hollywood movie *Battle: Los Angeles.*

Whatever you believe in, ghosts or UFOs, Point Fermin is a place with a rich history and vast, beautiful landscapes. Haunted Fort MacArthur (see Chapter 8) is only a short walk from Sunken City, as is the Korean Friendship Bell. Also within walking distance is one of only three Stick-style Victorian lighthouses left in the country, and one of the most haunted as well.

Chapter 7

BATTLESHIP COUNTRY

After the Civil War, the need for reconstruction was great and the Los Angeles Harbor was to become an important port of entry for trade with other Pacific nations bringing in much-needed goods. Since both the southern and the Union states had been decimated by four years of war, the leaders of the country were afraid that other nations might see an opportunity to attack or invade the West Coast of the United States and knew that it was paramount to build up a strong naval and military force in the area as a deterrent. The U.S. Cavalry had its hands full with the Indian Wars, so it would be up to the fledgling navy to provide the show of force that was required to dissuade any would-be aggressors.

As ships began to arrive in San Pedro, it became clear that the port itself was vulnerable to attack from the sea, so in 1888, the War Department took control of a parcel of land next to the harbor and began placing shore batteries to ward off any ships that might be deemed as hostile. Then, in 1897, it annexed the hilltop known as Point Fermin and initially used it as an observation point. In 1914, as war seemed imminent in Europe, the War Department grew worried and began a comprehensive program of defense for the Port of San Pedro. This became Fort MacArthur and would become the main coastal defense site for the Los Angeles area for many years.

Following World War I, tensions arose in the Pacific over Japan's position regarding China, and President Woodrow Wilson transferred two hundred ships from the Atlantic Fleet to the Pacific in a show of force for the Empire of Japan. At that time, San Diego was the main naval base on the West

This is where the battleships of the Pacific Fleet would have been anchored. This was Battleship Country!

Coast but was considered too shallow for the larger ships, so the battleships anchored in the San Pedro Bay under the protection of Fort MacArthur's fourteen-inch coastal guns. When Japan invaded Manchuria in 1931, the heavy cruisers of the Atlantic Scouting Force were sent to San Pedro to bolster the defense of the Pacific Fleet, and with fourteen battleships, fourteen cruisers, two aircraft carriers and the many support vessels to go along with the capital ships of the fleet, San Pedro Harbor became known as Battleship Country.

In April 1940, the Pacific Battleship Fleet sailed to Hawaii for combined fleet exercises to be held in and around the islands of Hawaii and Wake Island. With the tensions between Japan and the United States growing, it was decided to keep the fleet stationed at Pearl Harbor. Then, in July of that year, America instituted an embargo against Japan, limiting aviation gasoline and certain metals in the hopes that Japan would ease its aggression in Southeast Asia. The embargo had the exact opposite effect on the Japanese as had been hoped for and caused Japan to step up plans for possible war with the United States. As Japan asked for more time to negotiate an end to the oil embargo, it became clear that it was stalling. President Roosevelt decided that an even larger show of force was necessary and sent the entire

cruiser force, along with the submarines, destroyers and tenders, from San Pedro to Pearl Harbor.

When Japan attacked Pearl Harbor on December 7, 1941, San Pedro had virtually no warships left in its harbor other than support vessels. The city and port, however, was still to play an important and vital part in the war effort. The submarine base at San Pedro was the first on the West Coast of the United States, and even though it no longer functioned in that capacity, its docks and capabilities had been repurposed as a destroyer base and training facility. The Bethlehem shipyard in Terminal Island was churning out these small but powerful warships at a rapid pace, and the safety of the break wall and the training facilities at San Pedro were second to none. Naval Airbase San Pedro was a critical part in a chain of air defenses along the California coast, and Fort MacArthur became the primary induction center for troops heading to the Pacific Theater of Operations. The Fleet Post Office, fuel and supply depots, degaussing range, ECM repair facility, naval schools for small craft and firefighters and merchant marine communications, as well as fleet anti-submarine attack, all remained in San Pedro as well.

Prior to World War II, the San Pedro area had gained a large Japanese population. They mostly lived on Terminal Island and worked at the fish canneries or as fishermen selling their catches to Van Camp Foods, Chicken of the Sea or any one of the fish companies in the area. There was even one Japanese family who became entrepreneurs when they built a resort in the nearby Japanese farming community of Whites Point after the government closed the immigrants' fish cannery in 1908 over fear of them spying.

In 1915, Tojuro and Tamiji Tagami rented a large portion of land from Ramon Sepulveda for the purpose of building a resort centered on a natural sulfur spring that was at the base of the cliffs. Since Tamiji suffered from degenerative arthritis and had found that soaking in the spring greatly relieved his symptoms, the brothers wanted to bring those healing powers to everybody. The seaside spa became the Whites Point Resort. The Tagamis, with the help and financial support of Sepulveda, built a two-story, fifty-room hotel replete with a restaurant and dance floor, three saltwater plunges and a bathhouse for soaking in the sulfur spring. It became a popular tourist location for its sheer natural beauty and a place physicians would send their patients for the healing powers of the spring. Unfortunately, as is the fate of many places in California, the sulfur spring was sealed off in 1933 after a large earthquake hit the area. Even with this setback, the hotel still made enough money to keep it open, but as the economy continued to decline in the late 1930s and the rise of anti-Japanese prejudice increased, the resort

was forced to close. When the Japanese bombed Hawaii, all of the Japanese immigrants would soon vanish from the area as well.

After the attack on Pearl Harbor, the federal government took control of the remainder of Whites Point in an effort to bolster the defense of the harbor, and the entire area became part of the Fort MacArthur complex. The resort buildings and amenities were completely demolished, two large sixteen-inch coastal gun emplacements were constructed and machine gun and lookout stations were built. Then, soon after the war began, the War Department, with fear based on prejudice rather than fact, petitioned the White House to deal with the "possible threat of sabotage to the war effort by the Japanese." Under pressure from not only the War Department but also farmers seeking to eliminate Japanese competition, politicians hoping to gain favor by standing up to an unpopular group of people and a population with an unreasonable fear of Japanese Americans, President Roosevelt signed Executive Order 9066 on February 19, 1942, calling for the evacuation and relocation of all Japanese to relocation camps. These camps, ten in all, would be set up in Idaho, Utah, Arizona, Wyoming, Colorado, Arkansas and California. On February 25, those Japanese living in San Pedro were given forty-eight hours to evacuate their homes. Two days later, they were on their way to the camps. Most were sent to Manzanar Relocation Camp in the Owens Valley area of California. San Pedro has the distinction of having relocated one of the largest populations of people in history. (For more on the relocation and what it was like in the camps, read *Farewell to Manzanar*, by Jeanne Wakatsuki Houston and James D. Houston, Random House, 1973.)

In September 1941, the army had put out an extensive advertising campaign asking for dog owners to bring their large dogs along with the dogs' papers to Pershing Square in downtown Los Angeles for testing for use in the war effort. Once the dogs arrived, they were inspected, tested and many chosen for training. Later in the month, with newsreels running and reporters everywhere, the first dogs of the K-9 company walked through the gates of Fort MacArthur. Training was led by Sergeant Robert Pearce, and these sentry dogs became the now world-famous K-9 Command of the U.S. Army.

After the battleships, cruisers and other fighting ships were sent to Pearl Harbor, they never returned. The War Department had created a huge military complex in the Hawaiian Islands during the war, and as it was much closer to perceived threats, Oahu became the homeport for the Pacific Fleet. With San Diego being the main training center; San Francisco having a larger, sheltered harbor and logistics facilities; and Long Beach having the

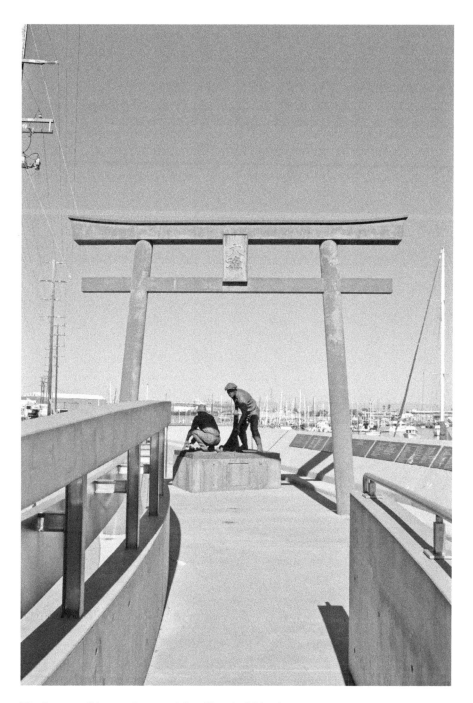

The Japanese fishermen's memorial on Terminal Island.

naval station and its repair facilities, San Pedro was deemed an unnecessary expense by the Navy Department and was quickly demilitarized. Today, the military presence in San Pedro is nonexistent. The U.S. Coast Guard maintains a station within the harbor, but as it is now under the Department of Homeland Security, it is not actually part of the military establishment.

Chapter 8

FORT MACARTHUR
MILITARY MUSEUM

This museum at the upper end of San Pedro has had a long history of paranormal activity. Although there have only been three deaths reported here—a soldier who committed suicide, a civilian contractor who died in an accident and a transient who was found dead at the museum and seems to have died from a heart attack—there have been many sightings of soldiers still going about the job of manning the battlements in defense of our country, as well as other, more strange apparitions.

The fort had its beginnings in September 1888, when the United States government gave land once belonging to Spain to the War Department. At that time, the port was in its infancy and still all but undeveloped, so there was not much thought given to building up the defenses around the fledgling harbor. This all changed in 1914 as the winds of war swept across Europe and the United States Navy ordered larger and larger warships. More land was acquired, and by the time the navy had begun stationing its new, modern ships in the Port of Los Angeles in 1919, Fort MacArthur had grown to include an upper reservation for coastal defense; a middle reservation for administration, housing and training; and a lower reservation for harbor defense. The fort itself was named in honor of General Douglas MacArthur's father, Civil War hero and Medal of Honor recipient Lieutenant General Arthur MacArthur.

When tensions arose between Japan and the United States in 1919 over the fate of China, President Wilson sent two hundred warships from the Atlantic Fleet to the Pacific coast, and due to the greater depth of the San

The museum entrance at Fort MacArthur.

Pedro Bay, the battleships were based in Los Angeles. Then, in 1931, as the Japanese invaded Manchuria, the heavy cruisers of the Atlantic Scouting Force were sent to bolster the growing Pacific Fleet. By 1934, the fleet based in San Pedro Harbor numbered fourteen battleships, two aircraft carriers, fourteen heavy cruisers, numerous destroyers and destroyer escorts and sixteen support vessels. It was during this period that San Pedro Bay garnered the nickname "Battleship Country."

After the 1937 invasion of China, the United States kept a close eye on Japanese expansion, and by 1940, it was felt that a greater deterrent was needed in the Pacific. In April of that year, the Pacific Fleet was relocated from San Pedro to Pearl Harbor, Hawaii. This would be the last time the navy would use Los Angeles Harbor as a major naval base of operations. Fort MacArthur, however, would flourish during the war.

Fort Mac, as it is commonly called, was still a major link in the coastal defense chain. Its fourteen- and sixteen-inch guns protected the Santa Monica Bay and were even credited with the sinking of a Japanese submarine off the coast of Redondo Beach in the month following the attack on Pearl Harbor. Its antiaircraft batteries will forever be linked to one of the worst cases of war hysteria ever recorded when, on February 25, 1942, at 3:00 a.m., every battery at all three reservations opened up

One of the old fourteen- and sixteen-inch gun emplacements.

with a hail of shells blasting at…well…nothing. There had been a report of enemy aircraft and ships in the area since the attack in December, and nerves were still on edge. When someone reported seeing "dark" silhouettes flying in the night sky, the reaction was almost immediate. No aircraft was ever found, no airborne explosions reported and, in fact, no proof of any kind was ever found to support the notion of an airplane flying in the blackout conditions of the area that night.

The "Great Los Angeles Air Raid," as it is now called, did more damage than it sought to prevent. With the amount of lead fired up into the air, the old adage of "what goes up, must come down" was put on display for all to see. Reports of damage came from areas as far away as downtown Los Angeles itself. To this day, conspiracy theorists have come up with many different ideas of what actually happened that night, but the UFO crowd seems to have won the urban legend battle, as the prevailing myth is now that of an alien invasion.

Fort Mac became the training site for the United States Army's famed K-9 Command. This internationally known unit had its beginnings in 1941 and continues today at army bases all around the world. Today, there is still a cemetery at this museum where some of the dogs that distinguished themselves in battle were given a hero's burial. It is believed that these dogs

are the reason there are sightings of spectral dogs patrolling the grounds in and around the museum itself.

When the war ended, Fort MacArthur became one of the main separation stations for the United States military on the West Coast. Soldiers would arrive back in the States and would be posted here awaiting their separation orders, which would allow them to return home. In all, some 151,000 men came home through the gates of Fort Mac, and the joy and relief they must have felt as they strode out of the middle reservation to renew their lives would have been great. Some believe that this sense of joy may have caused some of the men to return to the fort after their deaths and may be one of the reasons why we see so many apparitions.

After the war, the need for large gun coastal defenses was deemed obsolete in light of the new missiles being developed by the Soviet Union. It was decided to remove and scrap all of the guns and mortars that remained at Fort Mac, and in 1950, the fort was converted into a Nike missile command and control facility. There were numerous missile sites spread throughout the area, including Malibu, Torrance, Redondo Beach, the old Whites Point gun emplacement, Point Vicente (home to a reportedly haunted lighthouse) (see Chapter 10) and the fort itself; these were all controlled from Fort MacArthur.

Machine gun/observation site overlooking Point Fermin.

By 1974, the Nike missile had become as obsolete as the guns it had once replaced, and the army began the process of removing the missiles from their silos. With the need for monitoring the consoles and radar screens for incoming threats gone, the army now began reducing the personnel in and around San Pedro. By 1982, the property was turned over to the air force, but it was only interested in using it for military housing. The upper reservation was split up, with the majority being given to the Los Angeles School District and the Marine Mammal Care Center. Battery Osgood/Farley and Merriam/Leary were turned into the museum we enjoy today, and the middle reservation now has multiple uses. The lower reservation is gone.

Once the museum opened, reports of spirit activity began in earnest. The museum itself is located in between the two connecting gun emplacements that remain, and people have reported feeling as if they are being followed, but when they turn around, no one can be seen. There is a corridor that goes between the two batteries that is very narrow, very long and very dark. This corridor has been the number-one spot for reported paranormal activity. At one time, it was the only way to travel between the two sections of the museum, and many people claim that as they traversed this hall, they saw someone step into the corridor to block their way. This person would not move forward toward them but made it clear that he was not going to allow the guests to go any farther. When the museumgoers turned to go back the way they had come, however, they found that there was a figure blocking that way as well. Turning to see if both directions were indeed blocked, they found that the figures had vanished. Could this be the spirits of soldiers playing a prank on unwary guests—or perhaps something more?

There have also been many reports from guests of cold spots within the museum that seem to follow them as they explore the exhibits. These cold spots also seem to coincide with the sounds of boots running through the hallways even though there are no visible signs of the soldiers—or anyone else for that matter—running in the museum. It is believed that what is being heard are the residual sounds of men hurrying to their battle stations from times long past.

There are tunnels that span the upper reservation that are closed off to museum guests. These tunnels were used by soldiers to access the machine gun emplacements facing the shoreline to repel any attempted invasion or landing by an enemy force. A few of these "nests" are still visible on the hillsides, and many reports have come in over the years of people hearing phantom machine gun fire and the sounds of men quietly talking while on duty. There have also been reports from employees and

This tunnel is where the majority of paranormal activity is reported.

volunteers who have been inspecting these tunnels that they have heard people walking behind them, as well as whispered conversations from unseen specters.

There is an urban legend that has sprouted up over the years having to do with the explosion of one of the old fourteen-inch guns killing numerous soldiers. The legend has these men wandering the tunnels in and around the fort. The closest thing to this ever happening was an incident that occurred down the coast at Bluff Park. According to the staff at Fort Mac, in that incident, only one person was killed and one wounded, but again, this was not at the location of the museum today.

One of the unique aspects of this paranormal location is the frequent report of spectral dogs. Many people who come here and wander the grounds say that they see dogs running around as if traversing an obstacle course. It is believed that these animals are the heroes that are buried in the K-9 cemetery next to the front gate. Some of these dogs have even been known to come up to museum patrons as if they want to be petted. They always vanish as guests reach out their hands, startling more than one unwary person, to be sure.

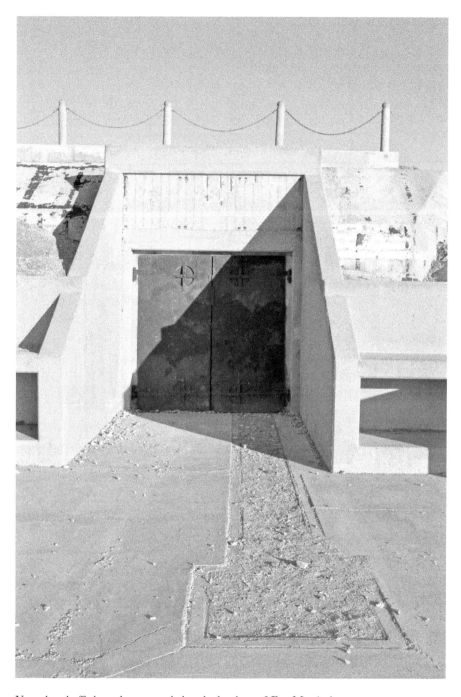

Now closed off, these doors once led to the bunkers of Fort MacArthur.

Just outside the gates of the museum, one can see a domed hill. Atop this hill is the Marine Mammal Care Center. What is not seen, however, is what is under this dome. The hill itself is hollow. Closed off now by the Los Angeles Unified School District, this hollow dome was once the barracks for the upper reservation. Here the soldiers of the Coast Defense Battalion would sleep, eat and gather after duty. This was home while in the army for these men. There are many reports from this area of the sounds of men laughing, the smells of food cooking, music and singing and also the mundane sounds of everyday life. For those paranormal investigators who are aware of this area, the barracks are a bucket list location. Alas, the school board is adamant about never allowing anyone access, especially those in the paranormal community.

Another area of reported activity is just to the north of the museum; this area is the mortar pit. Many movies have been filmed here, including *From Here to Eternity* and *Midway*. During filming of the movie *Midway*, members of the crew reported seeing extras watching from the shadows only to find that all of the extras were either on set or sent to the catering area outside the pit. Grips reported tools and props being moved, as well as cameras malfunctioning for no reason.

The Fort MacArthur Museum is located in a small area of the Angels Gate Park complex. The entire upper reservation compound is huge. There are reports of activity from all over the compound, but since the museum and its environs are the areas the general public uses the most, it is here that their paranormal reputation has grown. From the Korean Liberty Bell to the machine gun nests and giant gun emplacements, the Fort MacArthur Museum is a must-see when visiting San Pedro.

Chapter 9

WARNER BROTHERS THEATRE (WARNER GRAND)

Movies today have become less of an event and more a singular distraction from the troubles of everyday life. It was the same in the past as far as the diversion from life; however, movies and the movie houses where they were shown were a way for people to show off and a weekly event for the whole family, not to mention a place for young dreamers to imagine themselves up on the big screen, adored by millions of fans, their faces shown on the grand Art Deco screens of the day. The Warner Grand Theatre in downtown San Pedro is perhaps the last of its kind in the Los Angeles area and perhaps California as well; it is also one of the most haunted.

Construction began in the late 1920s, and when the theater opened in 1931, Jack Warner himself billed it as "the castle of your dreams." It was one of the most ornate movie palaces in the state at the time, with Warner Brothers sparing no expense to create one of the best examples of Art Deco architecture in all of Los Angeles. The Warner Grand in San Pedro is the only one of the three grand movie houses the studio built that still stands as it was intended. The theater in Hollywood is now an empty shell that stands all but vacant on Hollywood Boulevard, and the Huntington Park theater has been split up into business offices.

The three theaters were built to showcase Warner Studio movies, and the night the Warner Grand opened, January 20, 1931, there was a virtual who's who of the Hollywood elite—directors, producers and stars—on hand to watch the grand opening. The movie that played that first night was the studio's new hit comedy *Going Wild*, starring Joe E. Brown and a

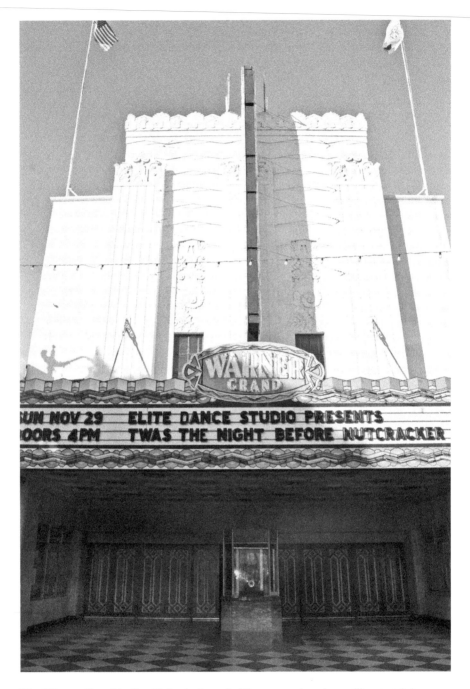

The Warner Grand in San Pedro is the only Warner movie palace still entertaining audiences.

young Walter Pidgeon. The guests were treated to live acts performed on a small stage directly below the big screen, which became a trademark for the Warners. It became the pre-movie entertainment, the same way the theaters today show trailers. All kinds of treats and snacks could be had not just by waiting at the snack counter but also courtesy of roving "Candy Girls" carrying trays full of goodies; there were even bathroom attendants on hand for the comfort of the theater's guests.

San Pedro at that time was a navy town, and the Warner Brothers Theatre was where the sailors would often take their dates to show them a good time. Even then, the town was a rough-and-tumble place of fishermen and deck hands who liked to drink and get rowdy, and the theater was an oasis of calm within this storm where their dates could feel safe while imagining themselves in the splendor of Hollywood itself. Its Art Deco interior was reminiscent of the theaters and movie palaces of New York's Broadway or Paris's Moulin Rouge. In essence, the Warner Brothers Theatre became the entertainment focal point for the entire harbor.

In 1948, the federal government decided a landmark legal case that had a sweeping impact on all the studios and their ownership of movie theaters. Because of a lawsuit brought much earlier by independent movie house owners, the studios were forced to give up their interest in the theaters and

The beauty of Art Deco is on display for all to see at the Warner Grand Theatre.

were forced to sell them to third parties in an effort to break up a perceived monopoly. Even though the studios no longer owned these movie theaters, they were still able to negotiate rates with the new owners for the rights to show their films along with the other studios' films. It was turning out to be a win-win for the public as well as the new theater owners. However, all good things must come to an end, and unfortunately, progress and television had much to do with the steady decline in the movie theater as a social hub as families began to stay home and get their entertainment from the small box in their living room.

The real decline of the grand movie palaces came when the giant shopping malls began to be built in the 1960s, and along with the department stores and novelty shops came the multiplex movie theaters. These multi-screen, multi-movie complexes became a one-stop, multi-choice theater experience that the single-screen movie houses just couldn't compete with. The decline in the movie palaces wasn't even a slow process by that time, and they began closing their doors rapidly throughout that decade and well into the 1970s. Few were left standing—mostly only those in small towns and remote areas of the country. Then when the VCR came onto the scene, even those began to disappear from the landscape of America. The Warner Brothers Theatre was no exception.

In an effort to save the Warner from the wrecking ball, the owners filed to have it placed on a list of historic sites, but even that couldn't save it from the decline in moviegoers. Finally, the Warner Brothers Theatre was forced to close its doors. There were quite a few attempts by new owners to resurrect the old place, but these were all fruitless until it was turned into a Mexican-language theater called Teatro Juarez. In this incarnation, it showed some new movies dubbed over but mostly films and shows from south of the border, which were popular with the growing number of Spanish-speaking denizens who were moving into San Pedro. While the theater was indeed keeping alive with this type of programming, the Art Deco splendor was completely lost. The owners of Teatro Juarez redecorated the magnificent building with gaudy Mexican trinkets, many of which could be found in the tourist stalls of Los Angeles's Olvera Street or downtown Tijuana, Mexico. Even the seats were reupholstered in a horrendous gold, green and red pattern that must have been from the mind of someone high on drugs. Unfortunately—or fortunately, depending on how one sees it—this didn't last long, and the Warner once again closed its doors. However, this time it looked as though it would be torn down and a new, modern building would take its place.

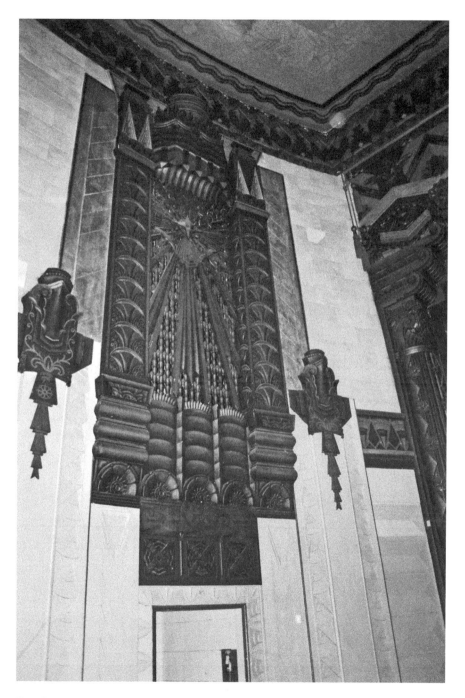

The Grand Vision Foundation restored the old theater to its former glory.

The building sat vacant for quite a few years, but in the background, a dedicated group of historians and preservationists was working to save the old theater. The Grand Vision Foundation won this battle in 1995 and in 1996 formed into a 501(c)3 charity and began the long struggle to restore the Warner Brothers Theatre and return it to its place of prominence in downtown San Pedro. The foundation began by forming the "Save our Seat" campaign, the sole purpose of which was to remove the ugly red, green and gold seats and replace them with original colors and fabric. The group restored the interior to its beautiful Art Deco elegance, but the road was long and costs were high. In 1999, the Warner Grand (as it was now called) was placed on the National Register of Historic Places, and today the foundation is just managing to keep the place from the wrecking ball by showing old movies, staging events and even renting the location to paranormal investigators for an evening of ghost hunting.

The Grand Vision Foundation has embraced the fact that the old historic theater is indeed haunted and has used this fact as a way to help bring in much-needed revenue by allowing investigators to try to gather evidence of the paranormal. This symbiotic relationship has been quite beneficial for both parties.

One of the most prolific spirits that resides at the Warner Grand Theatre is that of a man wearing what witnesses describe as "a fine suit and tie right out of the 1920s." There is some speculation that this specter may be none other than Jack Warner himself. While still alive, Jack made it no secret that the movie palace in San Pedro was his favorite. As it was not as crowded as those in Hollywood or the other locations, Jack would come here to relax and enjoy the films his studio was releasing and, later, those of the rival studios as well. He would always sit in the back row of the balcony, as this spirit always does, and would leave immediately after the movie was over to avoid being seen by the other moviegoers. This spirit also seems to disappear as soon as the lights come up. There have been many reports over the years of people seeing this apparition; he will always flash a quick smile before he simply disappears from view.

Another oft-reported spirit within the theater is that of a spectral projectionist. This dedicated employee of the Warner has been seen loading ghostly films into the projectors, rewinding films and watching all of the equipment as if waiting for a problem that might need fixing. This helpful spirit is not simply watching; he has on occasion actually lent a hand in fixing problems with the films before the audience or living employees have noticed there was a problem. More than once, a projectionist has come into the area

The back row of the balcony is where witnesses have seen a spectral theater patron enjoying the show.

and seen this spirit actually working on a film that is beginning to jam or slip a reel and have the problem corrected before the trouble becomes a catastrophe. No one knows the name of this devoted employee, but many of the current staff members are happy he is there to lend a hand in keeping their audiences entertained.

Investigators who have done research at the Warner Grand have recorded numerous EVPs (electronic voice phenomena) and photographed a plethora of orbs—if one is into orbs as spirit rather than dust—as well as heard many audible voices. One investigator reported hearing what she described as a "woman in her twenties" who was almost desperate to communicate with her, but she couldn't quite make her voice heard well enough to understand what she was saying. Another report from investigators is that of hearing music coming from the area where the orchestra pit used to be. The music that is heard sounds as if it could be from some old live musicals that the theater once staged. The tunes are always different and always fleeting.

One of the most active areas within the theater is actually an area where the public is not allowed to venture. This is the greenroom area under the stage where the actors and actresses would dress, apply their makeup and relax before going on stage. Over the years, the sounds of whispered conversations

have been heard even though the Warner Grand was empty except for those individuals who were listening to the disembodied voices. At other times, the smell of cigar smoke has been detected. The theater has not allowed smoking inside its doors for many years, so where the smoke is emanating from is a mystery. There have also been reports of the overwhelming smell of grease-based makeup even when there are no scheduled shows or makeup on premises. Strong scents of perfume have been reported along with the aroma of men's cologne.

Perhaps the most unusual yet most dynamic reports of paranormal activity come not from those inside the building but from those outside. Dating back many years, some of the local store owners near the old movie palace have told tales of having seen large groups of people milling about the front of the Warner Grand Theatre as if waiting for the doors to open before a show. In most of these stories, the shopkeepers say that the group of moviegoers are dressed in the style of clothing common to the 1930s or 1940s; this time span was the golden era for the old movie house. The Grand Vision Foundation is good about letting its neighbors know about any large events that might affect business, and these reports of paranormal gatherings never fall within the scope of actual scheduled programs of the theater. As mentioned, the witnesses who have seen these ghost gatherings

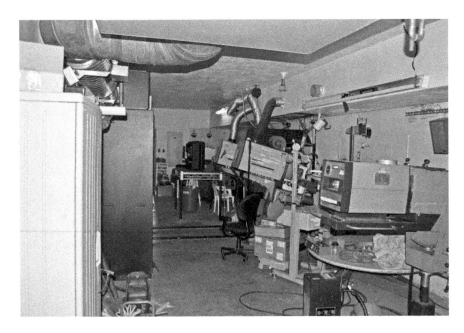

The projection room, where a ghostly employee makes sure that the show goes on.

have said that most of the time the spirits are dressed alike in the same style of clothing; however, there have been odd reports from these same witnesses that the gathered group is wearing a plethora of styles from many different eras, right up to what some call "bell-bottom '70s" clothes. It appears that this time-spanning group of spirits isn't even aware that they are gathered at the same place or that they are there with others from a different period than their own. They mingle about, but only within the group from their same era, it would seem. In every report, this group hangs about for a brief time and then simply fades from sight.

If you are into Art Deco or the lure of old theaters, as many people I know are, then the Warner Grand Theatre in downtown San Pedro is the place for you. It's an elegant, timeless reminder of when Hollywood and the age of movies ruled the land and families still went out on Friday nights rather than hunkering down in their solitary rooms typing frantically into a little box held in their hands and calling it socializing.

Chapter 10

POINT VICENTE LIGHTHOUSE

The Point Fermin Lighthouse isn't the only guardian overlooking the vast Pacific Ocean along the rugged cliffs of old Rancho San Pedro. Another, more modern beacon sits a mere seven miles north of the Point Fermin light and guides the ships until the light from Point Fermin can be seen by the vessels entering San Pedro Harbor.

Point Vicente was originally named Point Vincente by explorer George Vancouver in 1793 in honor of his friend Friar Vincente, who ran the Mission San Buenaventura. For unknown reasons, the name was changed in 1933 to what we know it as today. The first attempt to place a light on the point started in September 1907, when the Bureau of Lighthouses petitioned the federal government for funding for the construction of the beacon. A gas and whistling buoy had been installed years earlier, but it was discovered that vessels would still find themselves inside the buoy close to the sunken rocks, and many wound up grounded. Unfortunately, the government didn't take the threat seriously until 1914, when it was realized that the opening of the Panama Canal would greatly increase the amount of ship traffic moving up and down the coast of California. It was known that Point Vicente blocked the Point Fermin Light from ships heading south until they were within four miles of Fermin, so it was finally decided to erect the lighthouse at Vicente.

Due to Frank Vanderlip, who owned the property, not wanting to sell the twelve acres that the government wanted to buy and then the high cost of labor and material, it took until 1924 to put out bids for the construction of the light tower and outbuildings that would become the compound for the

The beacon tower at Point Vicente.

beacon. At one point, the government had been planning on putting the light offshore. President Woodrow Wilson even signed an executive order reserving the rocks at Point Vicente for "lighthouse purposes." Many of the bids received were rejected due to cost. The plans were then changed to call for frame construction with stuccoed exteriors and a tile roof for all three structures, and a bid for $36,990 was finally accepted.

The lighthouse began operation on May 1, 1926, as the brightest light along the coast of California. Its five-hundred-watt bulb shone through a brand-new, hand-ground, 5-foot, third-order Fresnel lens that cast the light out twelve miles at a rate of one flash every fourteen seconds. Due to the tower's position atop the bluff, the 67-foot structure's actual focal point for the lens was 185 feet and revolved on sixteen precision ball bearings, making this lighthouse one of the tallest and most modern in the country. Once complete, the total cost of the entire instillation came to $102,871, a small fortune in that day and age.

The first keeper at Point Vicente was George L'Hommedieu. He was brought down from Mile Rocks Lighthouse near San Francisco, along with Harry Davis from Alcatraz and Ben South from Piedras Blanca as first and second assistants, respectively. Almost from the start, there was tension between the three and their wives. Davis and L'Hommedieu had worked together before with no problems, but once they started their jobs at Point Vicente, L'Hommedieu, it seemed, couldn't get along with anyone. In 1925, Davis filed a letter with the district superintendent that charged the keeper with "using profane language and leaving the station without notifying the First assistant." Then, in 1929, new second assistant keeper Raymond Deurloo had L'Hommedieu charged with having made slanderous remarks and using foul language in the presence of the assistants; having threatened the lives of the first assistant and his wife; being intoxicated on station grounds; and failing to pull down the lantern room curtains after sunrise. After a full investigation of the charges, all three of the keepers at Point Vicente were reprimanded with no other action. Shortly thereafter, L'Hommedieu was transferred to Piedras Blanca Lighthouse, where he had no problems getting along with fellow keepers and was by all accounts a pleasant and affable man to work with.

In 1935, a radio station was added to the point with several tall antennas, a new dwelling for the seven radio officers and an attached radio room. The officers worked in shifts around the clock, receiving messages from ships up and down the California coast. The Point Vicente grounds now supported a lighthouse, fog beacon, foghorn and modern radio-receiving base.

The housing compound at Point Vicente, with the head keeper's house at right and the assistant keeper's house at left.

After the attack on Pearl Harbor, the entire West Coast of the United States was worried about Japanese aircraft, warships and submarines attacking the mainland, and the beacons from the lighthouses up and down the coast would make perfect guidance sources for the Japanese to follow. Many of these lights were extinguished—some forever like that at Point Fermin. Others, however, were deemed too important for Allied shipping, and these were only dimmed rather than turned off. Point Vicente was one of those classified as essential. Instead of being shut off, the five-hundred-watt bulb was replaced by a mere twenty-five-watt light. This would be just enough light for those ships that knew the rough position of the point to follow but too dim to be seen from out at sea and for those who didn't know where to look. Blackout curtains were also installed that the keepers could unfurl when warnings of enemy ships came in over the radio.

After the war, the curtains were removed and a more powerful light—one thousand watts—was installed. The Point Vicente Lighthouse was back up and running. During the war, the Palos Verdes Peninsula saw an increase in vehicle traffic, in large part due to military trucks and transports; because of this, the roads had been greatly improved. These improvements gave way to increased home building after the war, and many of those homes

were placed in the vicinity of Point Vicente because of the spectacular views. As the houses grew, so did the complaints about the beacon at the lighthouse. Drivers would protest the light blinding them as they drove through the area, and the residents would gripe about not being able to sleep or enjoy their evenings due to the incessant flashing. To alleviate the problem, the coast guard painted the landward side of the lamp room with a thick coat of white paint. This stopped the lens from flashing along the road and into the houses nearby. It was also at this time that the "Lady of the Light" made her first appearance.

The lighthouse was completely automated in 1971 but still retains its three keepers' quarters, a fog signal building, a radio room and a tower. Coast guard personnel still reside at the complex to oversee the grounds and to make sure that all of the systems stay running at peak efficiency, but the light, fog and radio intercepts are all automatic now. The original Fresnel lens still revolves in the lantern room and is still powered by its one-thousand-watt bulb, which rotates every twenty seconds and produces 437,000 candle power. It can be seen up to twenty-nine miles out to sea and is still saving lives to this day.

As stated above, the so-called Lady of the Light made her first appearance after the coast guard, in an attempt to block the landward side of the beacon, painted the lantern room windows a dull white. Almost immediately, reports from homeowners and drivers alike began to pour into the lighthouse office of a ghostly figure walking the tower's outer catwalk. The figure reported was that of a woman dressed in a flowing gown with long hair. The reports came so often that the coast guard personnel at the complex would actually stay up in the tower waiting for the ghost to appear. None of them was ever able to catch a glimpse of the specter, even though reports would come in from outside the gates at the same time the keepers were in the lantern room. This prompted the coast guard to change tactics, and in 1955, they again painted the landward glass with an even thicker, darker shade of white paint; after the new layer, all reports of the Lady of the Light stopped coming in.

Even though the reports about a spectral lady walking the tower stopped, there were other reports that did not involve the tower at all. It would seem that even though the Lady of the Light had vacated the lighthouse, she may not have left Point Vicente at all. Reports have been coming in for many years—some say even before the lighthouse was built—of a woman in a long, flowing white gown who floats along the cliff face atop the bluff at Point Vicente. Witnesses say she has long black

The light tower surrounded by a thick midday fog.

hair, and her face, when glimpsed, is that of a woman sad and distraught. Other viewers say that her hair is tangled and wet, but the rest of her description remains the same.

The identity of this lost soul is not known, but two stories have sprung up regarding this some say beautiful woman over the years. One story has it that this woman is the wife of a lighthouse keeper who either committed suicide or fell to his death from the cliffs one stormy night. As no keeper on record ever died in this manner at Point Vicente, I am pretty sure that this story was just made up as urban legend. The other, more plausible theory is that she is the wife of a sailor lost at sea. It is said that she was engaged to a handsome young man who promised to marry her when he returned from his voyage. When word arrived that his ship had gone down in a storm with no survivors, the distraught young woman threw herself from the cliffs in anguish. As reports say that a spirit of a young woman had been seen on the cliffs before the lighthouse was erected, this story may be closer to the truth.

Other reports from the area include a heavy fog that appears out of nowhere, and after it has enveloped visitors, voices can be heard calling out to them. These voices call their names, whisper to them and on occasion urge them to the cliff edge. Strange lights have been seen that move along

The fog-enshrouded cliffs where the Lady of the Light is often seen.

the top of the bluff and then mysteriously vanish, and on occasion, the sounds of cannon fire can even be heard from nearby. This cannon fire could be coming from the now abandoned gunnery range next door to the Interpretive Center that once belonged to Fort MacArthur.

Point Vicente was added to the National Register of Historic Places in 1979 and now serves as a coast guard auxiliary site and houses personnel stationed on coast guard ships based in San Pedro. It is also responsible for coordinating search and rescue operations along the Palos Verdes/Catalina Channel along with its lighthouse duties. Tours of the complex are given every second Saturday of the month for those wanting to ascend the seventy-four steps to the top of the tower. The views from Point Vicente are spectacular, and there are viewing points close by. I recommend traveling to this location for that alone.

Chapter 11

BB-61, THE USS *IOWA*

The Washington Naval Treaty of 1922 was an effort by the world powers to stem any arms race on the high seas by limiting the size of nations' warships. After the Battle of Jutland, where both the German and British navies suffered tremendous losses, it was feared that the nations of the world would try to build massive navies consisting of huge battleships and battlecruisers. If allowed to happen, this could build tensions around the globe, causing another world war. The Naval Arms Limitation Treaty, as it was officially called, put limits on the tonnage any warship could reach, along with limits on how many ships each nation could control at any given time. The limit placed on battleships was no more than thirty-five thousand tons standard displacement and a main armament limit of sixteen inches. None of the nations involved, including Japan and the United States, was happy with the arrangement, but all signed nonetheless.

Even though Japan had agreed to the stipulations of the treaty, it had already begun to break it before the ink had even dried. The Imperial Japanese Navy had already begun to secretly design and build two massive battleships, each weighing sixty-five thousand tons and each with nine giant, 18.1-inch main guns housed in three turrets. The size of the main battery, along with the fifty-two smaller support weapons, would make the *IJN Yamato* and its sister ship, *Musashi*, the largest vessels to ever sail the oceans.

The United States, in an effort to abide by the naval treaty, began construction of the *North Carolina* class and *South Dakota* class battleships, but at 37,484 tons and 37,970 tons, respectively, and both with sixteen-inch/.45-

The mighty sixteen-inch guns of the "Big Stick."

caliber main guns, both were woefully inadequate against the Japanese "super ships." However, once America became aware of the *Yamato* and *Musashi*, it immediately enacted an escape clause in the treaty and feverishly began plans to counter the Japanese warships. The result would become the greatest fighting ships in history, the *Iowa* class battleship.

The first vessel in the class and the only one of its kind to be designed with an admiral's bridge for flag duty was launched on February 27, 1942, and commissioned the USS *Iowa*, BB-61, with the motto "Our Liberty We Prize, Our Rights We Will Maintain." It left Chesapeake Bay for its first deployment on August 27, 1943, headed for Argentia, Newfoundland, before heading into waters near Norway to intercept the German battleship *Tirpitz*. So feared was the reputation of the new *Iowa* class that the German ship, upon hearing that the USS *Iowa* was hunting it, retreated back into the fjord it had been hiding in for most of the war. The *Tirpitz* would never see open water again.

The next assignment for the USS *Iowa* was to transport President Franklin Delano Roosevelt to Morocco for the Teheran Conference. This required that an elevator be installed for Roosevelt to get up to his quarters and a bathtub to be installed for the president to use while on board. This is one of the only U.S. naval vessels to ever have a bathtub

FDR's bathtub aboard the USS *Iowa*.

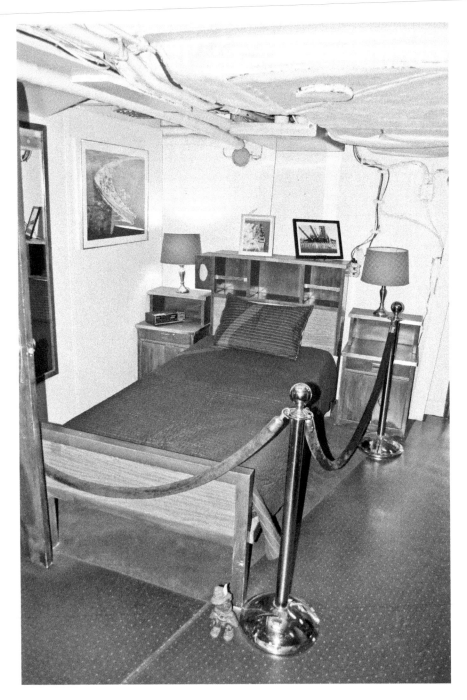

The captain's bed. This was commandeered by FDR when he traveled on board.

placed on board, and this tub can still be seen on the ship today. The *Iowa* waited in Casablanca for the president to return from Persia and then delivered him safely back to America.

After having the elevator removed from its deck, the ship sailed through the Panama Canal and into harm's way in the Pacific war. From Kwajalien to Okinawa and the battles of the Philippines, the USS *Iowa* took on the might of the Japanese army, navy and air force. It is said that the first time BB-61's guns opened up behind a U.S. Naval Task Force, the power of its full broadside was so great that the men on the surrounding ships thought it had been blown from the water. Once these men realized that it was the ship laying waste to the enemy, a great cheer rose up from the fleet before the other ships again started firing their own weapons. The USS *Iowa* took a hit from a Japanese shore battery along its port-side number-two turret. So good was the ship's armor that barely a dent was inflicted on the mighty battleship.

With the end of the war, the USS *Iowa* sailed into Tokyo Bay to receive the Japanese delegates on its decks for the signing of the surrender documents. At the last moment, President Truman, who hailed from the state of Missouri, changed the location of the signing to that of the USS *Iowa*'s sister ship and namesake of Truman's state. *Iowa* was still needed because it was equipped with more radio and transmitting gear than the USS *Missouri* due to its status as a flagship. So even though the signing took place aboard a different ship, the world heard it from the USS *Iowa*'s decks.

The ship was decommissioned on March 24, 1949, and placed in mothballs at Norfolk Naval Yard. When North Korea crossed the thirty-eighth parallel and invaded South Korea, the USS *Iowa* was called back into service. From April 8 to October 16, 1952, the *Iowa* was involved in combat operation off the east coast of Korea in support of United Nations troops as the flagship of Admiral Clark, commander of the Seventh Fleet. After this tour, it returned to Norfolk for an overhaul followed by a training cruise for new ensigns. For the next few years, the USS *Iowa* took part in numerous UN training operations and was the flagship for the Battleship Cruiser Force Atlantic and the Sixth Fleet, Mediterranean, twice before being decommissioned again in 1958. It again became part of the Reserve Fleet Atlantic, based in Norfolk.

One would think that with the advent of ship-to-ship missiles, advanced jet fighters with anti-ship capabilities and modern submarine weapons that were all arriving in the 1970s, the age of the battleship would have come to an end. That was not the case, however, and in 1984, President Ronald Reagan saw the need for these powerful ships in America's Cold War

against its Soviet adversaries. All four of the *Iowa* class ships were once again called into the service of the United States Navy. Almost all of the anti-air armament was removed, and four Phalanx CIWS (close in weapons systems) were added in their place. Four five-inch gun mounts were removed, but in their place sixteen Harpoon anti-ship missiles and thirty-two Tomahawk cruise missile launchers were installed, giving each battleship long-range offensive capabilities. Combined with the massive firepower of its sixteen-inch/.50-caliber main guns, they became the most powerful ships the world had ever known. With the armor protection from its main decks down to the incredibly thick anti-torpedo belt and the strength of its keel armor, the *Iowa* class ships were all but indestructible, even to modern weapons. A Russian admiral said of these ships after their relaunch, "Our ships will simply blanket you with missiles and gunfire until we have no weapons left to fire and then you will sink us." What better testimony to the power of these vessels than the praise of their enemy?

In 1989, one of the worst disasters to occur on a U.S. battleship took place when the USS *Iowa*'s number-two turret exploded during a gunnery exercise off the coast of Puerto Rico. The exact cause of the explosion has never been determined, but forty-seven men were killed that day, and the shock was felt throughout the ship. It destroyed the inside of the turret and traveled down the length of the turret stem to the bottom of the ship, destroying everything in its path. If not for the quick reactions of the crew, it could have been much worse. The ship managed to traverse the turret back to its forward position and continued on with its mission to the Persian Gulf region. Even though the mood of the crew was somber, they performed their duties with precision and honor until they arrived back in homeport.

The USS *Iowa* was again retired after a brief deployment to the Persian Gulf and in 1990 was sent to Suisun Bay near San Francisco and decommissioned, this time for good. The ship would sit and watch as its sisters—USS *Missouri*, USS *New Jersey* and finally USS *Wisconsin*—each in turn was saved from the breakers to become floating museums. *Iowa* would remain in limbo waiting in the cold Northern California air for someone to remember it was there. The City of Vallejo, California, stepped forward and claimed the USS *Iowa* but fell short of the monetary goal required for the navy to award the ship to it, and again the ship slipped back into obscurity and was close to becoming another piece of history lost to the welder's torch. Then, just when all seemed lost, the Pacific Battleship Center in San Pedro, California, stepped in and became the guardian of the greatest ship ever built. On July 4, 2012, the lead ship of the most

powerful and heavily armed American Fast Battleships ever built and, in fact, one of the last battleships ever built in the world opened to the public as the last battleship to become a living history museum. In its own way, it still serves the great country it was built to protect, and as it is still classified as "deep reserve" until the year 2020, it still stands ready to defend liberty even today.

Ships are known to draw spirit activity to them, or maybe it is just the sea that keeps its dead close. Whatever the case may be, warships are some of the most known for paranormal events, and the mighty USS *Iowa* is no exception to this phenomenon. It may just be urban legend or it may just be the sounds from an old abandoned hull, but reports have surfaced over the intervening years that the *Iowa* may be haunted. Whether these tales are true, I must leave up to my readers. Reports from some of the people when the ship first arrived in Richmond, where restoration began, were of strange noises and the sound of footsteps being heard on the empty ship. No one was sure what the sounds were, and they were put out of mind as the work of getting the ship ready for its trip to Los Angeles was the priority. Once the ship arrived in Los Angeles, however, things began to be noticed by those doing the work.

At first it was the same sounds that had been noticed in Richmond: taps, bangs, footsteps and the like, all of which could be explained away by the ship's state of repair; its emptiness, which could cause echoes; and the water warming and cooling around its steel hull, causing the metal to contract and expand. No one thought that anyone else might have inhabited the USS *Iowa*, least of all spirits. People began to notice things that they couldn't explain; tools that were missing would seem to turn up right where workers thought they had been left even though they were not noticed there just moments before. Tools that were needed would seemingly appear out of nowhere just when the volunteer needed them, and at one point, a worker who had been climbing a tall ladder began to fall but was saved by what he thought felt like a helping hand pushing him back onto the metal rungs, probably saving his life. When this worker turned to thank his savior, there was no one there, and he realized that he was so high up that no one could have reached him anyway.

This spirit became so well known that the crew gave him a name: the Chief. The first time the Chief came into existence was in the 1980s. He was the name the navy crewmen gave to any noise made by the machinery or hull that they could not readily identify. Those working on the battleship never felt threatened or ill at ease with the spirit; in fact, some of them

welcomed his help. Many thought that the Chief may have been a spirit local to Richmond but when the *Iowa* was towed down to San Pedro, the Chief came with it.

As in the Northern California port, the Chief would seem to lend a helping hand when those working to repair the ship needed him. The pace of repair was rapid as opening day neared, and it seemed that the Chief was all over the ship, helping where he could. Even today, when someone needs help, they may find it when least expected.

The Chief may not be the only spirit that calls the USS *Iowa* home. Since the ship arrived at its permanent berth, security officers have stayed the night on board, and many have heard what sounds like work parties below decks in areas that are off-limits to even the crew. As the security personnel are required to investigate these sounds to make sure no one has snuck aboard, many follow the sounds to their location, and once they arrive, all noise stops—that is, until the security officer leaves, at which point the sounds of work seem to again commence.

Third deck, or Broadway as it's called, is normally off-limits to guests and crew alike. There are times, however, when special tours are given down to this area. After the guests had all been ushered back to the common decks

Down this hatch is where the sounds of work parties are said to still be heard aboard BB-61.

after one of these guided trips, the guide and a security officer remained to make sure no one was left behind. As they were headed for the ladder, one of them turned and thought he saw a sailor leaning on the bulkhead opposite them. He was just leaning there, staring at the two and picking his nails. The men quickly ascended to the next deck and were stunned when they thought they saw the sailor still on their tail. They hurriedly headed for the next ladder, which led to the main deck, the open air and the sunlight. Once outside, they turned and saw that the seaman was no longer following them, and they began to relax, but even to this day, they have not forgotten their ghostly companion. Or it might have just been their imaginations playing with them while down in the empty, long hallways of Broadway.

The USS *Iowa* (BB-61) and its sister ships were built specifically to combat the threat of the Japanese super battleships. The *Iowa* came close to meeting its foe, but in the end, no confrontation between these titans ever happened. One can only guess at what the outcome would have been. Others, like myself, know full well which the victor would have been, and mercifully, all four are still with us today. The greatest of these is moored in the seaside town of San Pedro. It is a fitting end for the lead ship of this mighty class of battleships to be berthed in the port once known as Battleship Country and an honor for it to still be serving this great nation. It is an even bigger honor for those of us who work aboard to know that the sailors who served the "Big Stick" with such dedication and distinction are still performing their duties alongside us.

Chapter 12

SS LANE VICTORY

At the height of World War II, Hitler's U-boat wolf packs were sinking cargo ships at such a high rate that Britain and, later, the United States were hard pressed to keep up with the losses. The advent of advanced welding techniques and compartmentalized sections of the hulls had allowed the rapid construction of the Liberty ships, but due to inherent structural defects, many of the Liberties began to encounter hull cracks. Three of the ships actually broke in half without warning while in transit, with the loss of ten lives and a large tonnage of cargo. By 1942, it was obvious that a new design was needed, and in 1943, the new Victory ships started production. There were 531 ships of this class built during the war. Of those, only 3 remain: the SS *Red Oak Victory* in Richmond, California; the SS *American Victory* in Tampa, Florida; and the SS *Lane Victory* in San Pedro, California. The *Lane Victory* is now a fully functioning museum ship that sails four times a year; it is also one of the most haunted ships still afloat.

Laid down in April 1945, the *Lane* was launched less than two months later; it completed its sea trials in June and was delivered for duty on June 27. Its first wartime cruise began on July 2, 1945, to deliver supplies to troops on Manus Island in the Pacific Theater of Operations. By the time the *Lane* returned to port, Japan had surrendered and the war was over. That did not mean, however, that the job of the transports was finished. U.S. troops were still stationed all over the world, and they still needed to be fed and needed medical supplies, ammunition, fuel and all of the sundry items required for the occupation of the conquered nations. To this end, the *Lane Victory* pulled

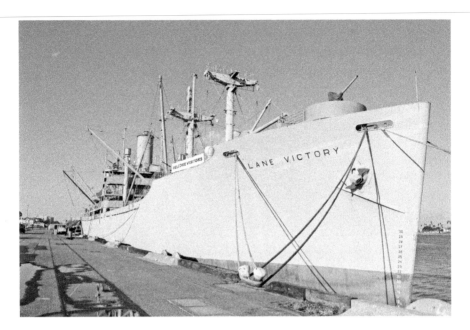

The SS *Lane Victory*.

into Pearl Harbor, loaded its hold with food and supplies and headed back out to deliver its goods to Saipan and Guam.

While on its second voyage, the SS *Lane Victory* ran into one of the worst typhoons recorded in the Pacific at that time. The small cargo ship was tossed about like a rag doll in Mother Nature's wrath for fourteen days. When the storm was over, the *Lane* was damaged but was still afloat and still very seaworthy. It is said that if one of the rigid Liberty ships had been caught in the same typhoon, it was quite possible that it would have broken apart and sank. The design of the Victory ships had again proven to be far superior to that of their older cousins. The *Lane* successfully delivered its cargo and returned to port, finishing its second voyage in February 1946.

With the war over and Europe in shambles, the United States developed a plan of aid that was the brainchild of Secretary of State George Marshall. It was a comprehensive recovery and aid package designed to help rebuild Western Europe. Even though the bill was not officially signed into law until 1948, the plan was implemented in 1946. After the SS *Lane Victory* returned from its second voyage in the Pacific, the ship was turned over for use in the Marshall Plan and made many trips "across the pond" delivering much-needed food, clothing, children's toys and essential items for the war-torn nations trying to rebuild after the most destructive war in history. The aid

plan ended in May 1948, and with its end, so expired the need for the large fleet of what was now deemed "surplus" cargo vessels. Many of the Liberty and Victory ships were sold off as scrap and sent to the breakers. A few were retained just in case the need again arose for them, and those were sent to various "reserve" locations around the United States. The SS *Lane Victory* was laid up in Suisun Bay near San Francisco.

When North Korea invaded the south in 1950, the United Nations intervened, and the *Lane* was again called back into service. In October of that same year, it had been completely restored to full operation, and it was again sent into harm's way, this time to help evacuate Korean civilians and UN personnel from Wonsan, North Korea. The ship arrived in enemy waters in December 1950 and began evacuation operations immediately. While on station at Wonsan, the *Lane Victory* rescued over 7,000 refugees. It then moved on to Hungnam and evacuated over 3,800 U.S. troops, along with 1,100 vehicles and five tons of supplies, during the Battle of Chosin Reservoir, all while under enemy fire. For the rest of the Korean War, the ship performed the duties for which it had been built and ferried supplies to the war zone from home and supply depot ports. With the cease-fire in effect, the *Lane* once again was mothballed at Suisan Bay on October 30, 1953.

In 1966, when President Lyndon Johnson escalated the war in Vietnam, the SS *Lane Victory* was again called up for duty. The ship was assigned with moving ammunition to the war zone from the United States, along with supplies needed for the front. For four years, the *Lane* would sail from the States with goods and arms for the troops and return with wounded and those soldiers headed home from the war. During its time in the Far East Pacific, the SS *Lane Victory* was the model ship and the standard by which all others were judged. When the Victory ships of the fleet were finally retired, the *Lane* was the last operational one sent to the reserve fleet at Suisan Bay. It sailed into the mothball fleet on April 29, 1970, its career seemingly at an end. By the time it was tied up at anchor, the SS *Lane Victory* had sailed to just about every port in the Pacific, had crossed the Atlantic several times and had even circumnavigated the globe on one of its many voyages.

Over the years, as the *Lane Victory* sat rusting and decaying in the salt air of the San Francisco Bay area, its sister ships were sold off one by one to the breakers. It seemed as if the once proud cargo ship was destined to follow and become scrap itself. However, a dedicated group of merchant marine veterans led by Joe Vernick and John Smith stepped in to save the ship, and on October 18, 1988, President Ronald Reagan signed into law HR 2032,

which granted to the United States Merchant Marine Veterans of World War II ownership of the SS *Lane Victory*.

The papers transferring the ship arrived in June 1989, and it was immediately towed from Northern California to Los Angeles Harbor. For the next three years, a group of volunteers, mostly retired merchant seamen, worked to get the *Lane Victory* up to modern coast guard standards. New electrical systems, boilers and fire suppression were upgraded or refurbished, and rigging, booms and winches were repaired. In December 1990, the SS *Lane Victory* was recognized as a National Historic Landmark, and with all of its interior and deck repairs finished, it was finally dry docked so its hull could get a complete inspection, after which the ship successfully completed sea trials. On October 3, 1992, the SS *Lane Victory* loaded passengers for its very first "Victory at Sea" cruise, and it has been entertaining and educating the public ever since.

Spirits and the afterlife seem to have a special affinity for ships. Why this is the case has always been up for speculation, but all one has to do to see this connection is look at how many vessels have been linked to paranormal activity around the world. Maybe it's the fact that the ships are surrounded by water, which has long been associated with spirit activity, or maybe it has to do with the fact that crews are living in such close quarters that their life energy becomes enmeshed within the wood and steel of the vessels themselves. Whatever the cause may be, the SS *Lane Victory* is no exception to this mysterious phenomenon.

One can not help but notice the many plaques lining the hallways of the ship as you tour the vessel. Each represents a Victory ship that was sunk during the war, and each lists the names of those crewmen who lost their lives in service to their country. The merchant marine seamen were not part of the military per se; therefore, if a merchant marine was lost at sea or killed, there was no official notification sent home to family members. Their loved ones would never know what really happened to their fathers, brothers or cousins other than they never returned home from the war. Maybe it is this lack of knowing what befell them or the fact that there is no one left to tell the family what became of these crewmen that keep them aboard, but as many will tell you, they are indeed still with us.

Even though the current staff of the *Lane Victory* insist that their ship is not haunted, the fact that they allow paranormal investigations of the vessel gives one pause. Why would they allow ghost hunters aboard if they truly believed there were no spirits still residing on the ship? Some of the reports coming from those who have investigated range from simple EVPs to loud

This leads down into the museum and the haunts below.

knocking, hearing whispers and even seeing apparitions. One group stated that while they were in the shaft corridor, they could actually hear the sound of men talking, and the voices began to sound frightened. This was followed by the sound of footsteps running toward an escape ladder. As the footfalls receded down the corridor, so did the sound of the men's voices. The group's guide informed them that if the ship was taking on water, the door would seal shut, and the only way for trapped crewmen to escape was to make a mad dash for the ladder. This same team of investigators also heard what they described as a girl singing; who this girl could be is a mystery, but she could possibly be connected to the large group of Korean refugees who came aboard during the Korean War.

Another section of the ship that seems to be active is a cargo area at the stern of the vessel. Here, groups have reported numerous shadows flitting about. These shades always appear just at the corner of the eye and seem to vanish when one tries to look directly at them. Again, no one is quite sure who or what these shadows could be, but considering the large number of refugees and the soldiers rescued from the Chosin Reservoir, it could be these who want to make their presence known.

Psychics who have come aboard have said that they have felt the presence of many sailors still residing on the *Lane Victory*. They have not been able to

determine if they are actual crew members or the spirits of some of the men and women who were brought on board from various rescue missions, but they felt them nonetheless. One such "sensitive" reported that she had gone into one of the bathrooms, but when she tried to leave, the door wouldn't budge. She claims that someone was holding the door from the outside, and she could hear smirking and chuckling from the other side. She said that she could "feel" that it was a sailor. She says that she tried and tried to open the door to no avail, and then in one final, desperate yank, the door was released, sending her careening into the sink. When she finally emerged from the bathroom, there was no one to be found in the corridor.

This psychic also said that she believes the museum area of the ship may be the epicenter of the paranormal on the *Lane Victory*. She claims that there are so many spirits there that they give off a palpable feeling of anxiety to anyone attuned to that sort of thing; it is as if the spirits are trying to tell people, "Go away, we don't want you here." She claims that they don't particularly like cameras either. They don't want to have their pictures taken and may push people to keep them from photographing the area. This psychic claims that a young, bespectacled sailor from the Vietnam War era follows people around, mainly women, and tries to dissuade them from snapping pictures. This fellow feels that it is disrespectful to the soldiers and seamen who remain on the ship. She said that the energy was so strong from the spirits pushing her to leave that she became physically sick to her stomach and had to rush out of the museum to keep from getting sick. As soon as she was back on deck, the queasiness subsided and she began to feel better. She said she believes that a few of these spirits actually followed her until she reached the bottom of the gangway.

There is one report that comes from the ship that has caused a lot of people to wonder at the cause. There have been many groups that have spent the evening aboard the *Lane Victory* and have said they have heard the sound of bowling coming from the cargo hold of the vessel. As there has never been a bowling alley or anything remotely resembling one on the ship, the sound has caused quite a bit of confusion. After speaking with crew members on the ship, as well as other seamen from different vessels, they told me that the sound most likely is coming from the hawsers being pulled tight against the ship and then loosening as the tide ebbs and surges. There are also certain types of fish that can attach themselves to the hull, which can cause a similar sound. This is most likely what is causing the spectral bowling heard at night when the ship is quiet.

Lining the halls of the SS *Lane Victory* are the plaques of the other Victory ships lost in the line of duty.

The SS *Lane Victory* was and is a marvel of what man can achieve during times of great stress. The fact that it was built and launched in just over a month's time is a spectacular feat of engineering that even today is hard to rival. The merchant marines who sailed this wonderful ship were all but forgotten by our nation but now finally are beginning to be recognized for their bravery and contributions to the war efforts they were involved in. It is hoped that one day the families of those who were lost in the service of freedom will finally learn what happened so they may be remembered as the heroes that they were. The United States government has finally begun to reward these men with pensions and the medals they so richly deserve for risking their lives on our behalf. For now, the *Lane Victory* and its two sister ships remain for us to visit and learn, and I highly recommend a trip to this wonderful ship. When you go, be sure to say hello to those sailors and others who remain on duty to this day.

Chapter 13

THE BUSIEST PORT AROUND

After World War II, the military all but abandoned San Pedro. Fort MacArthur still had its uses for a few years, but the lower reservation was deemed obsolete soon after the war. The large influx of men and material were no longer an issue, and the upper reservation was being converted for other uses.

When President Roosevelt sent the battleships to Hawaii in 1940 and later the cruisers and the rest of the Pacific Fleet, it pretty much spelled the end of the naval era in San Pedro Harbor. The repair facilities and base in nearby Long Beach would continue until the 1990s, as did the airbase on Terminal Island, but Battleship Country was finished. Bethlehem Shipyard was still churning out destroyers, but they would quickly leave as soon as they were complete, and in truth, the contracts for the small fighting ships were coming to an end as well. This would all seem to be a death knell for the now thriving port, but instead it helped create a booming community that even today thrives with one of the busiest ports in the world.

Terminal Island, once a bustling fishing community made up of mostly Japanese Americans, began to attract a large number of Hispanic, black, white and post-internment Japanese to work in the ever-growing canneries that were springing up all over the island. Todd Shipyard, as well as other, smaller shipbuilding companies, moved into the area, creating a further need for skilled labor. The railroads were now moving all over the port, either bringing in the needed shipbuilding material or hauling out canned fish by the tons for distribution to the rest of the country. Most if not all

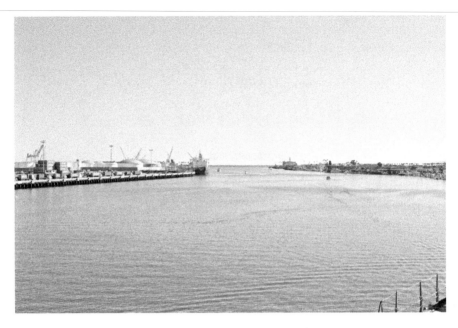

San Pedro Harbor with warehouse number one visible in the distance.

of this commerce was due to the massive build-up of infrastructure during the war.

As the country began to heal and grow stronger after the war and as the economy transitioned to a peacetime one, Americans again began to travel. Los Angeles and Hollywood had always been popular destinations for vacationing, and since the Red Cars still went all the way down to San Pedro, it was an easy side trip for viewing the Pacific Ocean while enjoying a good fresh seafood dinner at one of the local eateries. The powers that be recognized this and urged the business district managers to help build up the city's appeal. San Pedro was now being advertised as a destination rather than a side trip. It boasted of its scenic views of the ocean, its international cuisine and its port facilities, including the ease of travel to Catalina Island from its cruise terminal featuring the famous SS *Catalina*, otherwise known as the *Great White Steamer*.

Once the Red Cars stopped running in the '50s and early '60s, the tourist trade slowed down a bit, and the powers that be began to plan for the future of the area. The car culture had come crashing into the Los Angeles suburbs, and the construction of the four main freeways that had begun in the early 1950s had allowed for a large concentration of venues for San Pedro. It was now time to implement and build those venues, the first of which would be

the International Cruise Ship Terminal. Already a hub for those traveling to the scenic island of Catalina some twenty miles across the channel, a new and radical type of vacation was becoming popular, and San Pedro wanted to cash in on the new trend. Luxury liners were known for getting travelers from point A to point B in style and comfort. They were a way to get to your vacation destination and nothing more. Now, however, these ships became the destination; travelers would book passage on these new "cruise" ships as their hotel and entertainment venue while the ship sailed to a new daily destination for the travelers to explore before getting back on board to dine, dance, gamble and enjoy themselves until the next day and new location. San Pedro knew that Mexico would be one of these destinations and decided to capitalize on this new type of travel with its new terminal.

Local officials hoped to keep these travelers interested enough to stay in their town before and after their cruises and, at the same time, were trying to entice the Los Angeles locals to come to San Pedro for nighttime and weekend fun. With this in mind, Ports O' Call Village opened the same year as the new cruise terminal. This quaint, New England–inspired village had numerous novelty shops, fish restaurants, chowder houses and fish markets set along cobblestone walkways with an oceanfront view. Harbor cruises were offered, and sailboats abounded at the small boat pier out front. The village boasted that you could watch the many ships from around the world enter the harbor past your dinner or lunch table. For years, this fifteen-acre shopping and entertainment center was the pride of San Pedro.

The same year that Ports O' Call and the cruise terminal opened, so did the Vincent Thomas Bridge. This fourth-longest suspension bridge and the first welded bridge of its kind in the country was begun in 1960 but opened just in time to help in the resurgence of the downtown area of San Pedro. Until its opening, the only way to travel from Terminal Island east of San Pedro was to take a ferry across the channel, which inevitably required long waits and was not exactly the cheapest way to travel across the bay. Once the new bridge opened, even with its small westbound-only toll, those working at the canneries on the island had an easy way to get into San Pedro for a bit of dinner and nightlife after a long, hard day at work.

In 1959, the Matson Navigation Company sent its ship, *Hawaiian Merchant*, into the main channel of the Los Angeles Harbor and offloaded its cargo. This seemingly innocuous event would change the port, the shipping industry and, in effect, all of our lives to some degree. This ship delivered the first twenty cargo containers to the West Coast port and sparked a growth that is still continuing to this day. Before the advent of the cargo

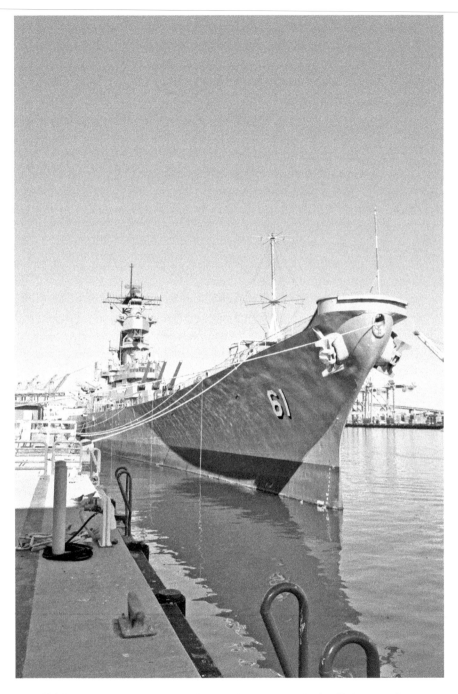

The USS *Iowa* is now a permanent addition and museum on the San Pedro waterfront.

container, shipments of goods were crated in boxes, bags, wooden crates and any number of receptacles, all unalike and all needing different means of loading and unloading equipment and manpower. This all translated into time. The new container system drastically cut back on equipment costs, and the standardization also made for more cohesive safety and manpower workload costs. In effect, things could be shipped cheaper, which meant the cost to the consumer went down. It was during this period that standardized car carriers came into favor, having the same economic windfall for the foreign import market and U.S. manufacturers having to pay less for their exported vehicles.

The growth of the container traffic into the port, with those ships growing larger and larger, created a need for a deeper channel within the harbor. This dredging was completed in 1983 to a depth of forty-five feet. In 1985, the port handled one million containers for the first time. This prompted the opening of the Intermodal Container Transfer Facility, which allowed for faster transfer rates of the containers to their awaiting distribution trains. In 1989, the rate of incoming containers reached a whopping two million. Since the opening of the container facilities, more dredging has occurred at various piers, more container sites have been opened and the port itself has become one of the leaders in clean air technologies and requirements for vessels in port. The Port of Los Angeles in San Pedro is now the busiest port in the United States and the third in the world, following China and Singapore. Unfortunately, this activity has not helped save San Pedro from a steady decline in quality of living and an economic downfall.

Over the years, with its aging housing assets, low-income housing designated by the City of Los Angeles and a growing influx of illegal immigration to the area, San Pedro has seen a steady decline in out-of-town visitors. This has caused a lack of funds coming into the city. One of the reasons that visitors have shunned the area is out of sheer fear. Gangs have taken over a large portion of the city, and the rivalry between these gangs has caused a growth in the crime rate, including random shootings and a high theft rate. Once the pride of San Pedro, Ports O' Call Village has become a place that families shun as it has become overrun with non–English speaking individuals. Almost all of the merchandise sold is in a foreign language, and there are beer bottles, fish bones and crustacean shells lying all over the floors of the outdoor eateries. This state of affairs has persisted for quite some time, but the city is definitely pushing to improve the situation. Over the last few years, there has been a concerted effort by city and business leaders at gentrification of the whole area. The downtown section has been

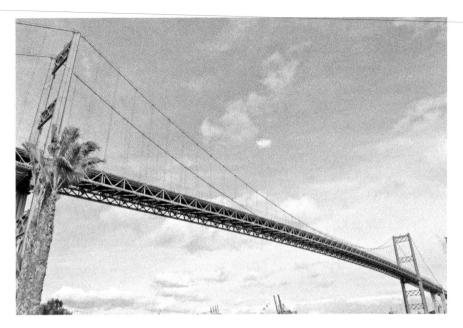

The Vincent Thomas Bridge stands as the official welcome to Los Angeles Harbor.

greatly improved, with fine restaurants moving in and others refurbishing to their once fine ambiance. There has also been an influx of new stores offering everything from clothes to books and even antiques. The waterfront has joined in with the building of a grand fountain, a craft and artist shop going into the once abandoned navy warehouse and the addition of a world-class museum when the battleship USS *Iowa* came to town as a premier attraction to the area. There are even plans to completely renovate the Ports O' Call Village back to its once prominent state and place in the community.

Chapter 14

A HAUNTING ON ELEVENTH STREET

No book about the history and haunts of San Pedro would be complete without talking about perhaps the most dramatic and one of the most violent cases in the annals of paranormal investigation. I am talking about the case known as "the haunting in San Pedro."

In 1989, Jackie Hernandez and her husband had a falling out, and Jackie, pregnant and with her two-year-old son in tow, left him and moved into a small bungalow on Eleventh Street in San Pedro. Over the next few months, odd things began occurring in the small turn-of-the-century home. Hernandez would hear strange mumblings and voices coming from her attic, objects around her home would move on their own and she would hear strange knocking within the cottage at all hours of the day and night. Jackie's cat, always playful, began chasing things around the house but in a way that was unlike her usual romps. It was as if the cat were chasing shadows on the wall but was always unable to catch them. There was a bed in the home that would collapse for no reason, and on occasion this would happen when occupied. On other occasions, a sticky red liquid would seep from the walls, and once, while Hernandez and a friend watched, pencils shot from their holder with enough force to impale someone but luckily landed harmlessly on the floor.

In April 1989, Jackie gave birth to a beautiful baby daughter. Her joy was short-lived, however, as she noticed that the activity in and around the small bungalow began to increase after she brought the baby home. It was around this time that Hernandez began having strange dreams. In

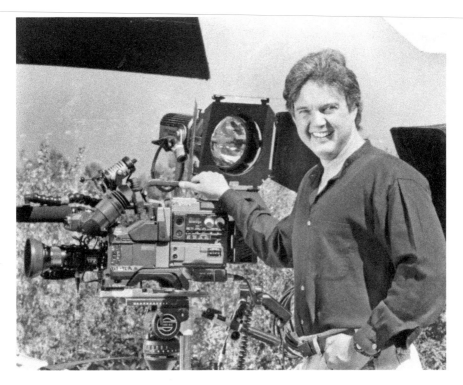

Barry Conrad, chief investigator on the Hernandez case. *Courtesy of Barry Conrad.*

her nightmares, she would dream about a young man being clubbed with a lead pipe and then being dragged down to San Pedro Harbor only to be held under the salty water until he drowned to death. The scene always looked the same in all iterations of the dream; it was San Pedro all right, but from the era of the 1930s. Each time Jackie had this dream, she didn't just see the events taking place in front of her but would actually become the victim. She would relive the horrible tragedy and would always wake up just as the poor man died.

The dreams continued for a few months. During one of these nightmares, Jackie awoke suddenly, drenched in sweat and shaking from the visions. She sat on the edge of her bed for a moment and then arose and headed down the short hallway. Before she could reach the bathroom, however, she glanced into the kids' bedroom and noticed an old man sitting on the bunk bed and glaring angrily at her. Before she could even react, the man vanished before her eyes. When the activity in the home started, Hernandez figured that she had been hallucinating due to her pregnancy, but now that her daughter had been born and after seeing this man around her children, she wondered if

she was going crazy. After this incident, the strange events surrounding her began to take over her life.

"In the beginning, it's all we talked about. Everyone thought we were crazy," said a close friend of Hernandez.

The activity continued, and Hernandez saw the old man once again in her home. This time the spirit was sitting at her dining room table; he was wearing old-fashioned overalls and looked "corpse like." She also saw a disembodied head appear in the attic in a frightening manifestation. The goings-on began to spill out into the neighborhood, as those living nearby noticed how disheveled Hernandez was becoming, and once, although no proof has ever been given, a neighbor who was taking a walk one evening claimed to have seen an old man standing in the street, staring at her until he vanished suddenly. Jackie Hernandez was afraid to reach out for help for fear of being ridiculed. It was her next-door neighbor who finally called Dr. Barry Taff after seeing him on television to ask if he would look into what was happening in the house. At first, Hernandez wouldn't even speak to Taff or his partners. Her fear of being made fun of kept her from accepting their help, but as things continued to escalate around her, she finally had enough and called Taff in August 1989 to come and investigate the occurrences.

Dr. Taff; Barry Conrad, a professional photographer; cameraman Jeff Wheatcraft; and a fourth investigator arrived at the San Pedro bungalow on August 8, 1989, to interview Hernandez and perform a preliminary sweep of the house. During the interview, the investigators began to get an uncomfortable feeling, almost the sensation that they were deep under water, as if pressure were compressing them. They could also hear noises coming from the attic; every now and again, the sound of heavy footfalls would be heard moving around above them. In the words of Dr. Taff, "It sounded as if a two-hundred-pound rat were running around the attic." Later that evening, while the team was doing its sweep, Wheatcraft went into the attic to have a look around and to snap a few pictures. He had been up in the dusty space for a few minutes when he heard a noise behind him. He knew that he was alone in the attic, so without turning around, he swung his camera in that direction and depressed the shutter. As the camera flashed, Wheatcraft felt it being violently pulled from his hand and heard it hit the opposite side of the attic wall. He would later find that the lens had been removed from the camera body and had landed several feet away from the camera, which was now placed inside a storage crate sitting on the attic floor. After hearing what had just happened in the attic, Conrad gathered up his equipment to record

the goings-on, but as often happens during paranormal events, every time he went up into the small space, his cameras would malfunction. Each time he came back down, his equipment would again work perfectly. He finally gave up, and the team prepared to head home. According to Taff, Wheatcraft was somewhat of a skeptic when he entered the tiny house, and his reaction to this event was "pure fear and some disbelief." The worst was still ahead for Wheatcraft, however, as it seemed one of the spirits in the home had taken an instant dislike to the affable young man.

The team ventured back to the San Pedro home of Jackie Hernandez the following month, on September 4, 1989, after Hernandez called Conrad to tell him that the activity had escalated since they were last there. The team was basically the same; however, Dr. Taff was unable to make the trip, so Barry Conrad brought along his friend Gary Boehm, another photographer. On this occasion, the group was lucky enough to witness the mysterious ooze that Jackie and others had been reporting and managed to gather a sample of the sticky stuff and send it to UCLA for analysis. (The forensics lab at the university determined that the liquid collected that had been seeping out of the woodwork at the house was human blood plasma.) Again the noises began up in the attic. This coincided with the group seeing lights flitting about the bungalow, three-dimensional orbs and a strange, floating, highly charged electrical light that shot through Conrad and stunned him. Conrad described it as a "warm and strong feeling."

Wheatcraft, still a bit frightened by his last encounter up in the attic of the small home, was nonetheless intrigued by these events and was more determined than ever to try to find out the truth behind what had happened. On this visit, he again brought his cameras, and he and Boehm ascended the ladder into the dark recesses to see if they could locate the source of the heavy footfalls they had been hearing. The two were in the attic only a few minutes when Jeff heard what he would later report as a snapping sound coming from behind him. The two men had split up, with Gary going to the front part of the attic, so Jeff knew that it wasn't him making the noise behind him. Jeff began to turn around, but before he could turn completely, he was violently yanked backward. He could feel something around his neck pulling him, and in an instant, he was dragged into a corner of the tiny space and found himself hanging by his neck. As Jeff was being pulled backward, he let out a startled yell. This caught the attention of Boehm, who immediately turned toward the sound. At first he was unsure what he was looking at and snapped a picture in the direction of Wheatcraft. As Gary got closer, he realized that Jeff was in trouble and rushed to free his friend from

the noose that was around his neck. They later discovered that a clothesline had somehow been tied around Jeff Wheatcraft's neck and had then been twisted several times around a protruding nail that was imbedded in one of the cross beams. There is no way that this could have happened by accident; this had to have been a deliberate act, but by who or what was unclear.

After Gary had helped Jeff back down into the main area of the house, they inspected his neck to make sure he was not gravely injured. After removing the still dangling garrote from around his neck, they discovered that he had serious rope burns circling his throat. There is video footage of the aftermath of this event, and watching it is quite chilling. Needless to say, after this event, Jeff Wheatcraft would never set foot in the San Pedro home again.

A little while after the events of September 4, Hernandez called Barry Conrad and asked if it would be OK to stop by and drop off something at his residence. When Hernandez arrived, Barry met her outside, they talked for a few minutes and then Barry returned to his condo. Within a few days of this seemingly harmless contact, Conrad began to have strange things occur within his home as well. He reported that chairs would move around and would usually end up in the way in the middle of the room; flashlights would mysteriously turn themselves on and be found that way in rooms where he hadn't left them; and once one of these flashlights was found, lit and balanced, facing upward in the middle of another room. Barry even once found his stove lit with the burner on high and bullets sitting next to the flame close enough to have gone off if they had stayed there much longer. It would seem in the brief contact Barry had with Hernandez the night she showed up at his house, at least one or more of the spirits followed her and decided to send Conrad a message.

A few months after the attack on Jeff Wheatcraft, Jackie Hernandez moved out of her San Pedro bungalow and to the small farming community of Weldon, California, in the Kern River Valley. She was trying to patch things up with her estranged husband and hoped that the move would be good for them both. At first, things were peaceful in her new trailer home, but they wouldn't stay that way for long. A few months after the move, things started to go wrong with her marriage again, and her husband moved out. Jackie was now alone in a remote, rural area with two young children and little contact with her close friends; she had made friends while in Weldon, but since they had families of their own, it started to become a rather lonely life. That's when the paranormal activity seemed to start up again.

It began as before, slowly, with faint knocking sounds, things seemingly moving on their own and other strange occurences. Then one day while

friends were helping Jackie move a television into a storage shed, they all witnessed as the face of a man suddenly manifested on the TV screen. The startled spectators hurriedly got the TV into the shed and quickly locked the door. Jackie knew the face that had appeared and realized at that moment that the spirit or spirits had followed her from San Pedro. Later that same night, Hernandez said she heard frantic knocking from inside the shed, as if someone were desperate to be let out. She immediately called on Conrad and Taff for help. Conrad and Wheatcraft made the two-hundred-mile journey from Los Angeles, but Taff was unable to make the trip due to personal responsibilities. As soon as Conrad and Wheatcraft arrived at Hernandez's trailer, they immediately noticed activity. Orbs of light were seen flitting about the room, Conrad and Wheatcraft were having trouble getting their equipment to function properly and at one point a tripod-mounted camera was seen twisting around the room all on its own. That's when a neighbor recommended they break out a Ouija board so they could try to communicate with the spirit haunting Jackie.

There is a lot of speculation regarding the use of these communicating devices. Somehow, it has become a tool for evil or for demons to come through or any number of evil suppositions. I am of the opinion that it is the same as any device, recorder, tape deck, etc. I will let my readers be the judge, however. Regardless of what you may think about the Ouija board, the neighbor brought one out, and the group began a séance of sorts. Barry Conrad reported that even before the séance began, the temperature in the trailer dropped to almost freezing, and the candles they had lit for light blew out a few times even though there was no noticeable breeze in the home. The session started with the usual questions of "Is there someone here?" and "Are you a ghost?" With both Barry's and Jeff's hands on the planchette, each time one of these questions was asked, it would move and hover over "yes."

In a transcript written by Hernandez and printed in the *LA Times*, some of the questions and answers are reprinted here:

> Q: *How long have you been trapped?*
> A: *Sixty years.*
> Q: *Did you die in the house?*
> A: *No.*
> Q: *Where did you die?*
> A: *San Pedro Bay.*
> Q: *Did you drown?*

A: No, I was held underwater.
Q: Did you live in the San Pedro house?
A: My murderer.

During the séance, one of the questions asked was why the entity had attacked Wheatcraft while he was investigating the attic in the San Pedro house. The answer they received was: "Resembles killer." They then asked the spirit why it had attached itself to Hernandez, and its response was "Energy." When asked what kind of energy it was drawn to in Hernandez, it responded "Dead." It is assumed that the spirit may have possibly been referring to negative energy emanating from Jackie, possibly because of the problems in her marriage and situation. It was right after this line of questioning that Jeff Wheatcraft was again assaulted by the entity in Jackie Hernandez's home.

Witnesses who were present at the séance, including Conrad, claim that while they were in the middle of a new line of questions, Wheatcraft, who was sitting quietly in his chair, began to levitate off the floor, chair and all. While the astonished group watched, the chair fell back to the floor, but Wheatcraft continued to rise up until he was violently thrown into the space where the ceiling meets the wall of the trailer. He fell heavily to the floor and lay there, unconscious from the impact, everyone fearing that the force of his body hitting the wall had killed him. He was not dead, thankfully, and when he awoke, dazed and unsure of what had happened, he told the concerned onlookers that while the attack had been occurring he felt the sensation of his diaphragm being compressed. The next thing he could remember was hitting the wall and waking up on the floor.

This séance started Hernandez down the road of trying to figure out who it was that was tormenting her. Armed with the knowledge that the spirit imparted to the group, she researched the San Pedro bungalow and any deaths that may have been associated with the area. She found an old newspaper article dated March 25, 1930, dealing with a man by the name of Herman Hendrickson. This seaman's body had been found floating under a pier in San Pedro Bay, and although the official cause of death had been ruled as accidental, he fit the details of what the spirits had described, right down to a cut on his forehead that looked suspiciously like an attack wound.

Jackie Hernandez moved back to Los Angeles in 1990 and continued to investigate the possible spirits in her old home on Eleventh Street. Hernandez found out that a man named John Damon—whom she believes was the old

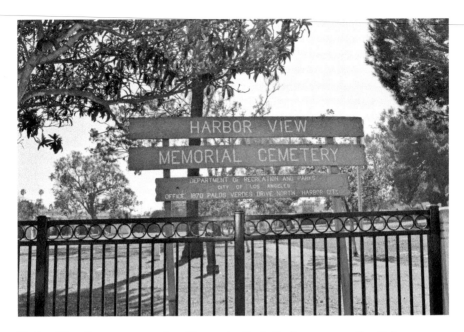

Harbor View Cemetery near where Hernandez lived after her return to San Pedro.

man she saw in her kids' room the night she awoke from a nightmare—built the bungalow. Hernandez thinks that Damon may have passed on finally and let her know by appearing to her one night and leading her to his grave at a cemetery near where she was living after she moved back from Weldon. The identity of the killer is another matter; Conrad believes that he may have found out the murderer's name. Conrad, after digging around in old records and clippings, believes that another seaman committed the dastardly deed. His name was Charles Pearson, and he had a reputation in the area as a mean customer with a violent temper. He also bore a close resemblance to Jeff Wheatcraft, as the spirit claimed during the séance. This helps but does not prove that Pearson was guilty of the crime.

The following theory put forth by Barry Taff concludes that the Hernandez case was never about ghosts at all. Taff believes that, like the "Entity" case he dealt with in the 1970s, what was actually occurring was a case of PK (psychokinesis) rather than spirits. As with Doris Bithers, Taff believes that it was Hernandez herself who was manifesting the activity surrounding her. He postulates that dealing with her failed marriage, a pregnancy, moving out on her own and a childhood filled with hardships caused her state of mind to manifest, via latent PK ability, the events that led to her neighbor calling Taff and the others to her home. Once the team

arrived and all attention was once again directed at Jackie, it satisfied her need for attention, and the occurrences grew exponentially. Once she had reconciled with her estranged husband, those needs subsided, and so, too, did the activity—that is, until her husband once again left her, at which point the poltergeist re-manifested at her trailer in Weldon.

Taff also has an explanation for why the PK attacked Jeff Wheatcraft, if it was in fact Jackie Hernandez who was directing the energy. According to Taff, Jackie had grown very fond of Barry Conrad over the months that they had been working together on the case. In her highly emotional state, Conrad had become her rescuer, a confidant and a friend—her savior, if you will. Although Conrad had shown no amorous feelings, nor had he made any attempts at connecting with Jackie romantically, Hernandez evidently misconstrued his easygoing, engaging attitude as an advance. The problem, according to Taff, was that every time Barry Conrad was near her, he was never alone. Jeff Wheatcraft was always there, getting in the way of her and Barry growing closer. In Hernandez's mind, Wheatcraft was a problem. This growing resentment toward Wheatcraft caused Jackie, or at least Jackie's subconscious, to unleash her PK on Wheatcraft in the form of violent attacks. These attacks were an attempt to dissuade Wheatcraft from ever returning to her home. As Hernandez was not a violent person, it is believed that she was not actually trying to kill him but to injure him enough to keep him away from Conrad and herself.

Taff stated during an interview taped for the news magazine show *Hard Copy* back in 1993 that he had asked Hernandez about his suspicions regarding her feelings for Conrad and that she had fully admitted she had feelings for him. She did not, however, admit to the attacks on Wheatcraft, and this line of questioning caused a great amount of confusion not only for the producers and crew of the television show but for the viewing audience as well.

It is hard to know what to believe in this case—psychokinesis or human spirits. Both seem to be possible. The fact that the activity surrounding Hernandez went away after she moved up to the Kern Valley only to return after her husband once again left her with two small children lends credence to the theory of Hernandez herself being the cause of the disturbance. However, the fact that the team of investigators managed to gather up a sample of the "goo" that had been seeping from the walls at the San Pedro home and that a respected forensics lab proved it to be human blood plasma leans more toward it being a spirit situation. So, too, does the fact that both Hernandez and Conrad have found evidence linking actual people to the

The grave of the cottage builder. Did his spirit lead Hernandez to his grave?

reports gathered from the séance. I am afraid that it must be up to the reader to decide which is true.

The small house on Eleventh Street in San Pedro is still there, pretty much the same as it was when Hernandez was the tenant. Over the years, many who have rented the bungalow have stayed only a short time. They claim that odd happenings within the house are their reason for leaving. The frequency of these residents abandoning the cottage has dwindled over the years, and current occupants have reported no paranormal activity now for quite some time. A co-worker of mine who owned the home next door to the bungalow told me that his neighbor just laughs when confronted by ghost hunters who ask if they can investigate the home; he politely explains that he lives there and does not want to be disturbed and that the ghosts have moved away. That may in fact be the case, but who is to say that they won't return for a visit?

Chapter 15

THE WAYFARERS CHAPEL

Nestled within the quiet and peaceful hills of Rancho Palos Verdes, an area once inside the vast Rancho San Pedro, sits perhaps one of the most beautiful churches in the entire United States. If it is not the most beautiful, then at the very least it is the most unusual. The Wayfarers Chapel is made almost entirely of glass. Redwoods and Christmasberry trees surround the entire area in an artful way in an effort to evoke serenity and calm in the many visitors who flock to this tiny church along the rugged cliffs of the Pacific Ocean, disturbed only by the ghosts that roam the compound and the specters of the past.

The Wayfarers Chapel had its beginnings in the late 1920s, when Elizabeth Schellenberg had a dream to build a church to honor Emanuel Swedenborg. This theologian and scientist who lived in the 1700s was the founder of the Swedenborgian denomination of the Christian church to which Elizabeth belonged. Narcissa Vanderlip, who was also a member of the sect and from the wealthiest family on the peninsula, donated three and a half acres of land for the project. Vanderlip also contracted renowned architect Ralph Jester to draw up the design plans for what would be called the Wayfarers Chapel. Unfortunately, the Depression of the 1930s, followed by World War II, delayed any development, and nothing was done until after the war was won.

During the intervening years, Jester mentioned the chapel project to his friend Lloyd Wright, son of famed Frank Lloyd Wright and a brilliant architect in his own right, and after the war, Jester urged him to get involved

A view of Wayfarers Chapel showing the "forest" setting.

with the project. After learning about the Swedenborgian philosophy of harmony between God's natural world and the inner world of mind and spirit, Wright found that he couldn't refuse working on the church. Having once visited the majestic redwoods of Northern California, Wright had envisioned building a cathedral that would bring the grandeur of the forest together with the inspiration of God into one harmonious structure. Here he found his chance to make his dream come true.

The dedication ceremony took place on July 16, 1949, by the Reverend Dr. Leonard I. Tafel, the president of the National Order of the Swedenborgian Church. Construction began shortly thereafter and was completed in 1951 to great fanfare. Schellenberg's dream of a chapel where wayfarers could stop and rest, meditate and give thanks to God for the wonder and beauty of creation was realized. Once finished, the "Glass Church," as it was being called, was rededicated as a memorial to Emanuel Swedenborg. It stood out as a sentinel, alone on a bluff overlooking the rugged coastline, and as an inviting spot for travelers to view the blue Pacific. So significant was this little chapel on the hill to the area and Los Angeles in general that none other than the renowned actor Charles Laughton, the man who played Quasimodo in the film *Hunchback of Notre Dame*, gave the dedication speech.

Over the years, several other structures and additions were added to the property, all designed with an emphasis on nature and an eye on enhancing the beauty and peacefulness of the landscape. In 1954, the Hallelujah Tower was erected, sidewalks and planters were installed and the now oft-visited reflection pool was placed on the grounds. In 1957–58, the colonnade and visitors' center were built, and then in 1964, the baptism font was installed. Even while all these man-made structures were being erected, the redwoods and other trees that had been planted according to Lloyd Wright's design were growing, and other gardens were planted along with the original flowers and bushes, with the end result becoming a small redwood forest surrounded by the color and beauty of nature in all of its glory framed by the wild and rugged Pacific Ocean, with Santa Catalina Island in the background.

Given the fact that the Wayfarers Chapel is not only one of the most beautiful settings in Los Angeles but a working church as well, it has become one of the premier destinations for weddings from all walks of life, including several celebrity and notable unions. In January 1958, Jayne Mansfield got hitched to Mr. Universe, Mickey Hargitay. In the 1980 movie about Mansfield's life, the wedding scenes were also shot at the Wayfarers Chapel. A relatively unknown actor played the role of Hargitay; this actor's name is Arnold Schwarzenegger. In 1971, Gary Berghoff, who played the beloved Radar O'Reilly on the TV show *M*A*S*H*, was married in front of the stone waterfall altar. Beach Boys front man Brian Wilson was married here in 1995 and said this about the Glass Church: "The vibrations in that chapel were so wonderful." But perhaps the most star-studded union that took place at the Wayfarers Chapel was that of Dennis Hopper and a twenty-two-year-old ballerina who was thirty-one years his junior. This fourth marriage for Hopper lasted only three years, but in attendance were notables such as Carol Kane and Kiefer Sutherland, as well as his ring-bearer, Roddy McDowall. Astronaut Anna Fisher and Governor Earl Warren recited their vows here; other stars spotted here over the years include Debbie Reynolds, Carroll O'Connor, Pat Nixon and none other than Bob Hope himself.

One of the other unusual things about the Wayfarers Chapel is the amount of activity the site gets from Hollywood. As mentioned previously, *The Jayne Mansfield Story* had scenes shot at the church due to the fact that Mansfield actually got married here. It has also been seen in many films and television shows since. In 1989, the blockbuster movie *Innerspace*—featuring Dennis Quaid, Martin Short and Meg Ryan—filmed the final scenes of the movie at the Glass Church. *It's a Mad, Mad, Mad, Mad World* included a brief scene at the church, as did the 2014 movie *Endless Love*. Hollywood isn't the

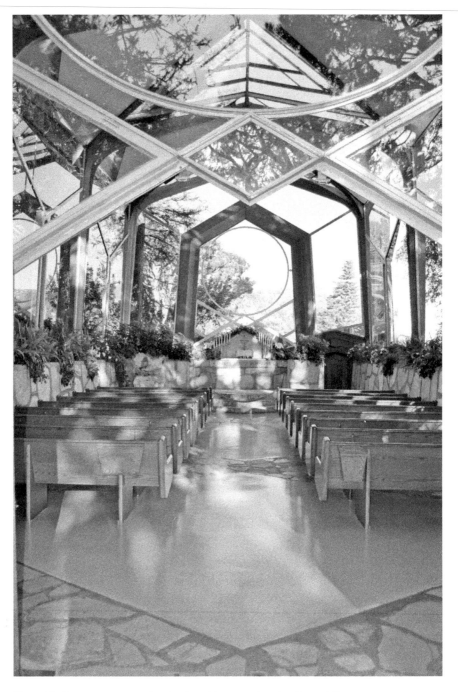

From this shot, you can see why the chapel is so sought after for weddings.

only medium to have utilized the stunning location; many television shows have included the chapel's beautiful grounds.

The Fox teen drama *The O.C.* filmed the wedding of two main characters, Julie and Caleb, here, and later, when Caleb died, his funeral was held here as well. The Wayfarers Chapel doubled for the Hamptons in the television series *Revenge* when it saw the wedding of Emily Thorne to Daniel Grayson in one of the show's most-watched mid-season finales. Season nine of *The Bachelorette* saw Desiree and new husband Chris off on their dream wedding, and the Wayfarers Chapel became the Panticapaeum Institute in season two of *True Detective.* There have been so many television shows filmed on the grounds that it would take too long to list them all; suffice it to say that the Wayfarers Chapel has appeared in science fiction to westerns, *Sliders* to *Hunter,* and everything in between.

Frank Lloyd Wright Jr. once said about his chapel on the hill:

> *The great cathedrals of redwood inspired me to use the redwoods here. In early days all over the face of the earth there were chapels in glades and the woods, which were meeting places for priests and the people. The chapel was to be a place for people to meet, and think and contemplate the forces of nature and God Almighty. The setting of this Chapel is to receive people, the wayfarers.*

Wright did his job well. His church invites those wayward travelers with its serenity and beauty. It seems to have attracted other, less tangible wayfarers as well—those that have not yet realized that their life in this plane of existence is now over and it is time to move on.

Many people who have come up to the chapel over the years and wandered the gardens have reported what they originally thought were one of the grounds' caretakers. The first thing that catches their eye is that he is dressed in Native American garb as he busily picks weeds and tends to the flowers and plants about him. Thinking he is an employee of the church, guests have approached him to ask about the many plants, only to have him vanish in front of their eyes before they can speak. When these guests ask about this gentleman of the clerks in the gift shop, they are told they don't know what they are talking about or are told that there is no such employee at the church. Who this old man is has been lost in time, but many believe he is one of the native Gabrielino Indians who inhabited this land before the Europeans arrived.

Another strange happening at the site is the appearance of a giant white owl that will become visible right in front of guests. There will be no sound of

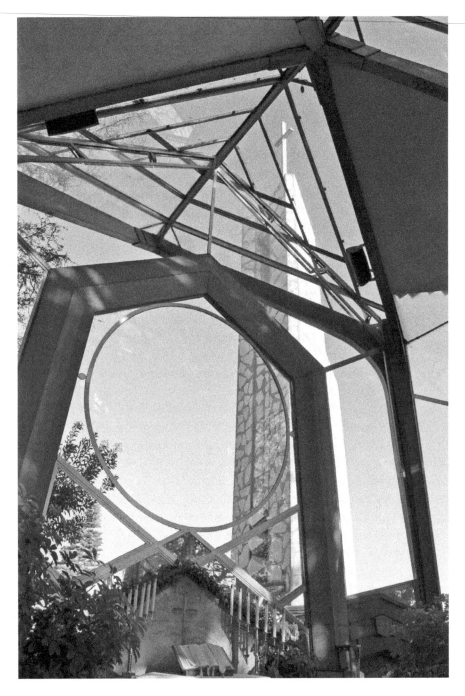

A view of the spire from inside the chapel.

wings or the noise of the giant bird settling on the branch or bush it appears on; it simply is just there. This owl is never threatening or hostile; it simply looks at the person or people it is interested in, with its head turning slightly from side to side as if listening, and then flaps its wings and disappears. It is believed by many to be a good omen and usually can be spotted around the same days when the spectral Indian makes his presence known. Others believe that the owl is the Indian's guardian and that the reason they are seen close together is that the owl is keeping watch over his charge. No one knows for sure.

Urban legend has taken hold at the Wayfarers Chapel, and because of this, there are many amateur ghost hunters who now stalk the location at night. Part of that legend, and one that seems to have been borne out, is the sudden appearance of a wispy fog that will blanket the entire area even though the night is clear and the weather warm. Strange lights and orbs can be seen floating about, and witnesses have reported the sound of distant voices calling out. Sometimes these voices call out the names of the visitors as if beckoning them forward to join them. It is said that there is a cemetery in the hills behind the church, but if there is, it is long forgotten and its location lost.

The Vanderlip Mansion, the home where Narcissa Vanderlip lived and grew up, is nearby the Wayfarers Chapel. Abalone Cove and Portuguese Bend are directly in front and to the side, respectively, of the Glass Church, and all three of these locations are said to be haunted as well, which could be one of the reasons the chapel is haunted. It would seem that the entire area is a veritable spectral playground of sorts. The area was and is sacred to the Gabrielino/Tongva people, and maybe the curse that some say they placed on the Europeans who took their land is to blame. Or maybe it's just the beauty of the area itself that makes one want to spend eternity here. Whatever the case may be, the Wayfarers Chapel is one of those places that is a must-see if traveling to or visiting San Pedro.

Chapter 16

THE VINCENT THOMAS BRIDGE

There had always been a need to connect Rattlesnake Island to the city of San Pedro and Long Beach. At first it was by rowboat, and then, after the fishing fleets and canneries began to grow, it was a ferry. But there were those who dreamed of an easier, more convenient way to get onto the area that became known as Terminal Island.

The first bridge to connect Terminal Island with the mainland came about by a need for the U.S. military to quickly get across to its bases on the island during World War II. This resulted in the army corps of engineers erecting a pontoon bridge on the east side of the island connecting Long Beach to its bases. Then, in 1948, the Commodore Heim lift bridge was constructed, allowing access from the north. That just left the main channel of Los Angeles Harbor as the only area to still use a ferry service to get San Pedro residents from their homes to their jobs on the island. The municipal ferry replaced the private service in 1941 and traveled from Sixth Street across the one-thousand-foot span at six knots, or approximately seven miles an hour. Unfortunately, the automobile ferry stopped running at nightfall, and then only pedestrians would be moved using a second wooden ferry—not really very convenient for night shift workers.

After World War II, the port saw a great increase in imports. Trade from all over the world flowed into the area daily, and much of that was offloaded on Terminal Island. Then, when containers entered the scene, the ship traffic grew even more. Couple that with the oil industry growing in the area

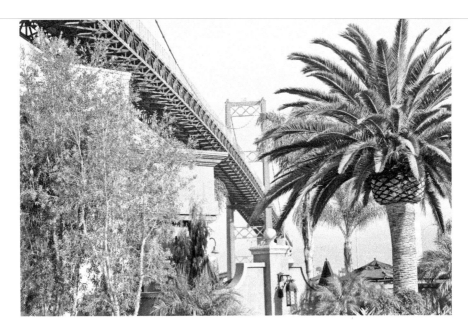

The Vincent Thomas Bridge is not only one of the longest but perhaps also one of the most beautiful bridges in the state.

and the large fishing industry, and it became clear that something had to be done to get the goods moving faster off of Terminal Island.

Enter Vincent Thomas. Thomas first ran for public office in 1940 and was successful in becoming the state assemblyman for the district representing San Pedro. From almost his first day in office, he lobbied the state for funds to build a bridge connecting San Pedro to Terminal Island, where many of his constituents were employed. Thomas knew full well that the growth of the port would necessitate a need for faster movement from the docks to the city of Los Angeles, and he knew the only way to accomplish this was a bridge. Many of his detractors were calling his pet project "Thomas's bridge to nowhere," but this didn't stop him from aggressively pursuing his dream for the area.

Many different options were suggested over the years on how to get goods and the public from the island over to San Pedro. One that was seriously considered was a two-lane tunnel under the channel. Many believed this option better than a bridge that might restrict ship travel up the inner waterway, but when it was found that a bridge was almost as cost effective, and with Vincent Thomas still pushing for the span, it was finally decided in 1958 to fund the bridge project.

Design and engineering plans were begun, and it took until 1960 for the blueprints to be approved. They were changed many times due to the very concerns that had been raised earlier by those opposed to the project that the height would restrict certain vessels from passing underneath to the upper channel. Construction of the San Pedro/Terminal Island Bridge, as it was called, began in late 1960 to great fanfare. There were many who were upset that Thomas, who had championed for the bridge for decades, didn't seem to get any recognition for his tireless fight, so in 1961, in a very unusual step, the California legislature changed the name of the bridge in honor of someone who was still living. The San Pedro/Terminal Island Bridge would now be called the Vincent Thomas Bridge.

On Saturday, September 28, 1963, in one-hundred-degree heat, in front of Mayor Sam Yorty, State Controller Alan Cranston and a whole host of state, local and government dignitaries, as well as a large crowd of San Pedro and Terminal Island residents, the new Vincent Thomas Bridge was dedicated. It was not a coincidence that the ferry service shut down on November 14, 1963, at 9:30 p.m. and the bridge opened to traffic at 12:01 a.m. on November 15, 1963.

When the bridge opened, it became the fourth-longest bridge in California, the first welded bridge in the United States and the only suspension bridge in the world supported entirely on piles; it is still the only bridge in California to have been named after a still living (at the time) person. The 2.2-mile span cost $21 million to construct, which is now less than the yearly cost of maintaining the bridge. The toll was eliminated in the year 2000, so the state is responsible for the entire upkeep. Painting alone takes one thousand gallons of zinc, five hundred gallons of primer and one thousand gallons of green paint to cover the entire span. By the time crews get to the other end of the bridge, it is time to begin again back where they started. In 1996, the Los Angeles City Council declared the Vincent Thomas Bridge the city of Los Angeles's official welcoming monument. It may not have known or may just be ignoring the fact that there may be more than a bridge welcoming people to the city.

One of the things that had never been considered at the time the Vincent Thomas Bridge was being designed was the fact that many a disturbed individual thinks of a long, high bridge as a way of ending his or her life; as such, the bridge itself has been the site of many sad and tragic events. Not only have many suicides occurred on the span, but there have been many fatal collisions and accidents as well.

The Vincent Thomas Bridge has become, regrettably, one of the most prolific suicide bridges in the state. The Los Angeles Police Harbor Division has said that at least one attempt a month is recorded at the bridge but will not state how many are successful. One can only imagine that with that many attempts, not everyone can be saved. In fact, there have been quite a few famous people who have sought the bridge for this very reason, the most recent being the brother of Hollywood director Ridley Scott. Tony Scott was a famous director in his own right—having directed such films as *Top Gun*, *The Hunger* and *Unstoppable*—yet people never seemed to recognize his name. It is hard to understand why, but on August 19, 2012, his body fighting terminal cancer, Scott threw himself from the bridge, with many witnesses to this horrific act. Suicide is always a tragic end to a life, and that tragedy can and will leave its mark on an area. With the amount of this type of death on the Vincent Thomas Bridge, it should come as no surprise that some of these lost souls have remained at the spot where their lives ended.

Over the years, reports have come from drivers crossing the span of seeing people jumping from the bridge. Some of these have been new suicides; however, there have been many instances where authorities have been unable to locate any victims from these reports. The Los Angeles police and

The lobby of the Catalina Cruise Terminal is said to be haunted by the many people who have ended their lives by leaping from the bridge.

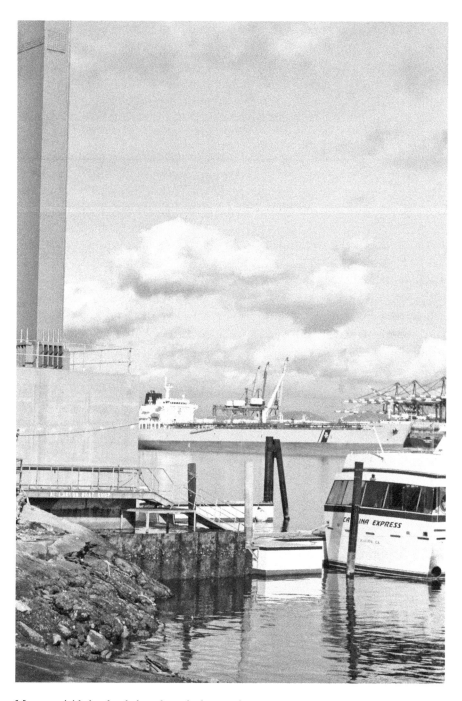

Many a suicide has landed on these docks over the years.

sheriff's rescue and recovery teams are some of the best in the world, and it is unheard of that they would not be able to find jumpers' remains, so who are these phantom suicides the drivers see on the bridge? Many have been reported at the same time of day and at the same location where some of the more famous cases have occurred. Could these be the residual imprints of a person's final, horrified moment of realization of what they have just done to themselves?

The Catalina Cruise Terminal is directly beneath the western approach of the bridge, and its pile—the docks for the boats that transport passengers—is also under the span. Many times jumpers miss the water and impact with the docks or the concrete behind the terminal itself. There have been many reports from those working at the terminal of seeing "passengers" who appear lost and confused wandering around on the docks and these other areas even after the terminal has closed and the boats are tied up for the night. When these specters are approached, they vanish from sight as if they had never been there. Many people have also claimed to hear the sounds of impact on the docks and grounds, as well as screams that come from nowhere.

One of the most tragic reports of paranormal activity comes from an accident that occurred in the early 1990s and seems to repeat itself. One evening, a family was driving home from Long Beach after having spent the day enjoying themselves at the beach. As they were driving up the westbound approach of the Vincent Thomas Bridge, an eighteen-wheeler veered into their lane, causing their mini-van to swerve, hit the side rail of the span and flip over numerous times. The entire family was killed in the accident. Since that time, reports have come in of people seeing the van driving up the road, hitting the rail and then vanishing. Other people report seeing the family wandering the bridge near a wrecked mini-van before the entire scene simply fades away.

The Vincent Thomas Bridge is a marvel of technology and a beautiful symbol for the city of Los Angeles and San Pedro as well. Authorities need to understand the draw for those suffering and do more to prevent the tragic loss of life associated with the span; for those who are hurting and in need, I implore you to seek help before you decide to make a permanent solution to a temporary problem. As someone who has had friends commit suicide, I can tell you it not only affects those who die but also those who must live with the result and the guilt of not being able to help. Please, seek support and live!

BIBLIOGRAPHY

THE DOMINGUEZ RANCHO

Dominguez Rancho Adobe Museum. "History." dominguezrancho.org/history.
Social Studies Fact Cards: California Ranchos. "Rancho San Pedro." factcards.califa.org/ran/sanpedro.html.
Wikipedia. "Battle of Dominguez Rancho." en.m.wikipedia.org/wiki/Battle_of_Dominguez_Rancho.

POINT FERMIN LIGHTHOUSE

Lighthouse Friends. "Point Fermin, CA." www.lighthousefriends.com/light.asp?ID=97.
Point Fermin Lighthouse. "Lighthouse History." www.pointferminlighthouse.org/history.html#more.

POINT FERMIN'S SUNKEN CITY

Gateway. "Sunken City—San Pedro, CA." gateway.bigforumpro.com/t671-sunken-city-san-pedroca.

Littlejohn, Donna. "Sunken City in San Pedro Would Be Open to the Public During the Day Under New Proposal." *Daily Breeze*, May 11, 2015. www.dailybreeze.com/government-and-politics/20150511/sunken-city-in-san-pedro-would-be-open-to-the-public-during-the-day-under-new-proposal.

M. Bros. Media. "Beyond Sunken City: An Urban Paranormal Phenomenon!" Vimeo. vimeo.com/36933605.

POINT VICENTE LIGHTHOUSE

Ghost Hunters of Urban Los Angeles. "Free (Haunted) Lighthouse Tours (Pt. Vicente)." ghoula.blogspot.com/2010/05/date-1st-saturday-of-march-time-1000am.html?m=1.

Lighthouse Friends. "Point Vicente, CA." www.lighthousefriends.com/light.asp?ID=95.

Sights of Palos Verdes. "Point Vicente Lighthouse." www.palosverdes.com/pvlight.

Thorne, Tamara. "13 Creepy Southern California Haunts." cdn.spundge.com/stories/9650/embedded.

BB-61, THE USS *IOWA*

Hull Number. "USS *Iowa*." www.hullnumber.com/BB-61.

Military Factory. "USS *Iowa* (BB-61) Battleship." www.militaryfactory.com/ships/detail-page-2.asp?ship_id=USS-Iowa-BB61.

SS *LANE VICTORY*

Ghost Watch Paranormal. "SS *Lane Victory*." www.ghostwatchparanormal.com/#!s-s-lane-victory/c2099.

Global Security. "Victory Ship Design." www.globalsecurity.org/military/systems/ship/victory-ships-design.htm.

The Gravel Ghost. "The Ship." thegravelghost.com/2013/01/10/the-ship.

Lane Victory. "About the SS *Lane Victory*." www.lanevictory.org/laneVgeneral.php.

Wikipedia. "SS *Lane Victory*." en.m.wikipedia.org/wiki/SS_Lane_Victory.

A Haunting on Eleventh Street

Abrams, Garry. "Tangled Tales from the Crypt?: For 3 Years, Jackie Hernandez Says She Was Followed by a Pair of Puzzling—and Persistent—Ghosts." *Los Angeles Times*, March 23, 1993. articles.latimes.com/1993-03-23/news/vw-14352_1_jackie-hernandez/2.
Ghost Theory. "The Haunting of Jackie Hernandez." February 7, 2009. www.ghosttheory.com/2009/02/07/the-haunting-of-jackie-hernandez-a-haunting-in-san-pedro-ca.
Taff, Dr. Barry. "Hazardous Hauntings: The Enemy Within." June 22, 2012. barrytaff.net/2012/06/hazardous-hauntings-the-enemy-within.

The Wayfarers Chapel

Gnerre, Sam. "Wayfarers Chapel: 'The Beauty of Glass Expanded the Spirit.'" Daily Breeze, April 29, 2009. blogs.dailybreeze.com/history/2009/04/29/wayfarers-chapel-the-beauty-of-glass-expanded-the-spirit.
Highfill, Samantha. "'Revenge' Wedding: Where Have I Seen That Church Before?" Entertainment Weekly, December 16, 2013. www.ew.com/article/2013/12/16/revenge-wedding-the-oc.
Seeing Stars. "Wayfarers Chapel." www.seeing-stars.com/Churches/Wayfarers.sh.tml. HA
Wayfarers Chapel. "History." www.wayfarerschapel.org/your-visit/history.

The Vincent Thomas Bridge

Gnerre, Sam. "South Bay History." *Daily Breeze*, October 21, 2009. blogs.dailybreeze.com/history/2009/10/21/the-vincent-thomas-bridge.
The Native Angeleno. "Vincent Thomas Bridge Fact Sheet: The Original Bridge to Nowhere." August 21, 2012. www.thenativeangeleno.com/2012/08/21/vincent-thomas-bridge-fact-sheet.
The Port of Los Angeles. "CA-47 Thomas Vincent Bridge." www.portoflosangeles.org/transportation/ca_47.asp.

GENERAL HISTORY

The Port of Los Angeles. "History." www.portoflosangeles.org/idx_history.asp.
The San Pedro Coast. "History." thesanpedrocoast.com/history.
Taylor, Alan. "World War II: Internment of Japanese Americans." *The Atlantic*, August 21, 2011. www.theatlantic.com/photo/2011/08/world-war-ii-internment-of-japanese-americans/100132.

BOOKS

Clune, Brian, with Bob Davis. *California's Historic Haunts*. N.p.: Schiffer Books, 2015.
Dwyer, Jeff. *Ghost Hunters Guide to Los Angeles*. N.p.: Pelican Publishing Co., 2007.

ABOUT THE AUTHOR

B rian Clune is the co-founder and historian for Planet Paranormal Radio and Planet Paranormal Investigations. He has traveled the entire state of California researching its haunted hot spots and historical locations in an effort to bring knowledge of the paranormal and the wonderful history of the state to those interested in learning.

His interest in history has led him to volunteer aboard the USS *Iowa* and at the Fort MacArthur Military Museum, as well as give lectures at colleges and universities around the state. He has been involved with numerous TV shows, including *Ghost Adventures*, *My Ghost Story*, *Dead Files* and *Ghost Hunters*, and was the subject in a companion documentary for the movie *Paranormal Asylum*.

His other books include *California's Historic Haunts*, published by Schiffer Books, and the highly acclaimed *Ghosts of the* Queen Mary, published by The History Press. He is also working on his next book, *Murder Obscura*.

Clune lives in Southern California with his loving wife, Terri; his three wonderful children; and, of course, Wandering Wyatt!

Visit us at
www.historypress.net
...
This title is also available as an e-book

CPSIA information can be obtained
at www.ICGtesting.com
Printed in the USA
LVHW071553220321
682104LV00015B/2340